BASIC
DRAWING

LOUIS PRISCILLA

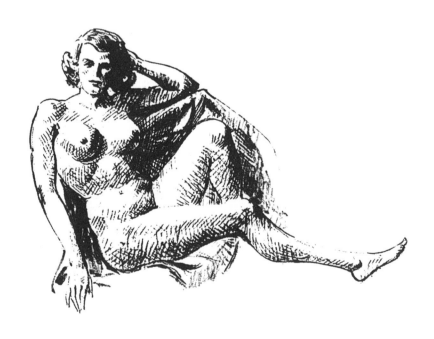

DOVER PUBLICATIONS, INC.
Mineola, New York

Bibliographical Note

This Dover edition, first published in 2007, is an unabridged republication of the work originally published by Bramhall House, New York, in 1954.

Library of Congress Cataloging-in-Publication Data

Priscilla, Louis, 1906–1956.
 Basic drawing / Louis Priscilla.
 p. cm.
 "This Dover edition, first published in 2007, is an unabridged republication of the work originally published by Bramhall House, New York, in 1954."
 ISBN 0-486-45815-6 (pbk.)
 1. Drawing—Study and teaching. I. Title.

NC730.P75 2007
741.2—dc22

2006102447

Manufactured in the United States of America
Dover Publications, Inc., 31 East 2nd Street, Mineola, N.Y. 11501

PREFACE

The inspiration for this book grew out of the many problems of the students who have attended my classes at the Art Students League of New York.

After years of teaching I have learned the basic needs of students in their quest for artistic knowledge. Consequently, I have attempted to present basic rules that may be applied toward a well rounded education in all branches of drawing.

I have purposely avoided the discussion of techniques, mediums and materials. I believe that every artist has an individual style of his own, separate and distinct from others. Each person will find by trial and error the best materials suited for his own interpretation and manner of working.

I have tried to present informative facts rather than ideology. There have been countless books written on the various subjects found here. I have met many students who have become confused by lengthy explanations about simple rules that could be explained in a few lines. Consequently I have kept the text to a minimum and I have tried to make the drawings as self explanatory as possible. The drawings in this book were made to incorporate simple rules of procedure with the hope that they may help to give you a solid foundation with which to work. If they do this, only then will this book justify its publication.

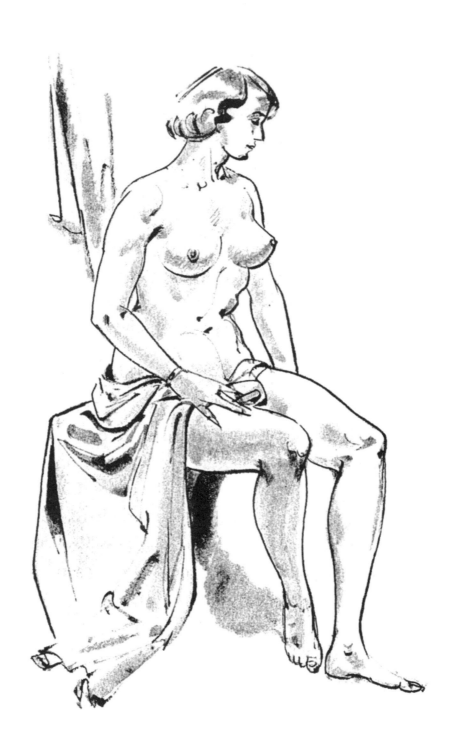

CONTENTS

PERSPECTIVE

Without the knowledge of perspective, constructive drawing is impossible. Leonardo Da Vinci called it the "bridle and rudder of painting." Every form, from a grain of sand to a mountain, exists in perspective. It is the first thing a student must learn. Like the alphabet in a language, without it, one would not be able to write. Too many students by-pass this phase of learning. The knowledge of perspective makes it possible to create the illusion that objects and figures are three dimensional on a two dimensional surface such as a sheet of paper, canvas or wall.

There are three basic forms in nature: the square, the circle and the pyramid. Every object fits into these three shapes or a modification of them. The square can be a cigar box or a sky scraper, or any form with six sides. The circle or sphere can be a pea, an observation balloon or a wheel. The pyramid can be a church steeple or the pyramids of Egypt.

The muscles of the human figure can be put into any of these shapes. Knowing the names of the muscles and bones is not sufficient knowledge to draw the figure. If this were so, every good doctor would be able to draw the human figure. One must know the shape of the parts of the body and be able to put them in perspective.

The mere copying of anatomical drawings will not teach one to draw the figure or to create one without the model. There is no other field of study in which students fail in greater proportion than in art, because of by-passing the study of perspective. Its importance cannot be over-stressed. Every great painter understood its laws.

In the following pages I have tried to show a simple approach to the subject.

With the knowledge of a few simple squares such as a radio, a match box and a package of cigarettes put together becomes a group of buildings. As shown on Page 9, Page 12 and Page 13 two photographs of a shipping department are changed into two cities. The interior of a room is nothing more than looking into a box. If one is able to draw a tube in perspective, it becomes simple to understand the fore-shortening of arms and legs of the human figure.

When beginning a drawing or picture, first establish your eye level by drawing a line across your paper. It will correspond to the level of your eyes in relationship with the object or scene that you are drawing. For example, if you are sitting in a chair drawing a model who is standing in front of you, the level of your eyes will be at about the waist of the model. Every form above the eye level will recede downward to the eye level and every part of the model below the level of your eyes will extend upward to the eye level.

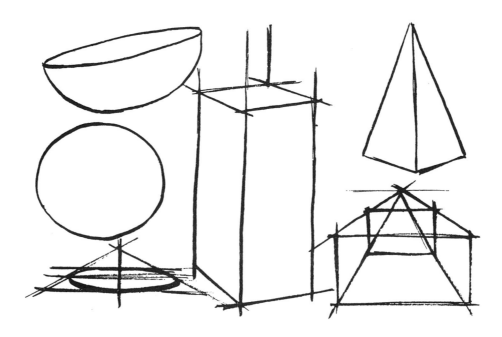

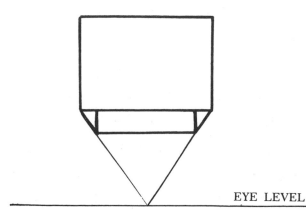
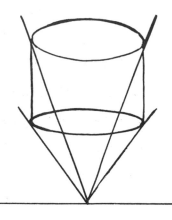

EYE LEVEL

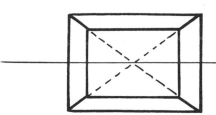

EYE LEVEL

EYE LEVEL

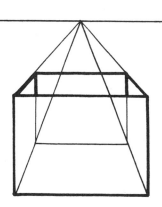
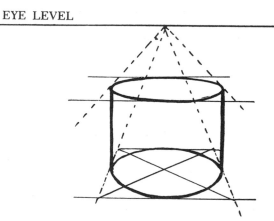

Apply these principles to any square object around you. Place a book in front of you without being able to see the sides but just the front and top and draw it using one point perspective. Try it with a table or chair or any six-sided square, then turn the same objects so you can see three sides — front, side, top using two point perspective.

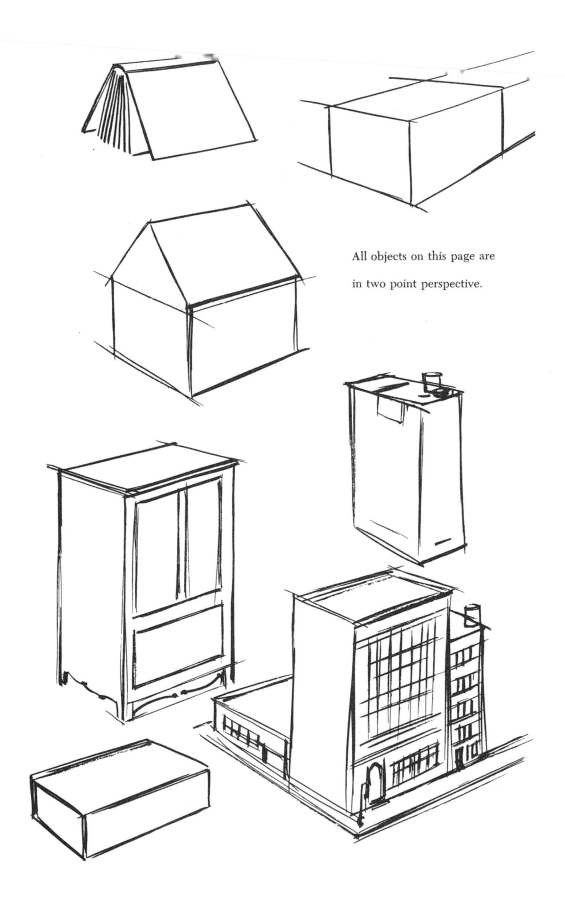

All objects on this page are
in two point perspective.

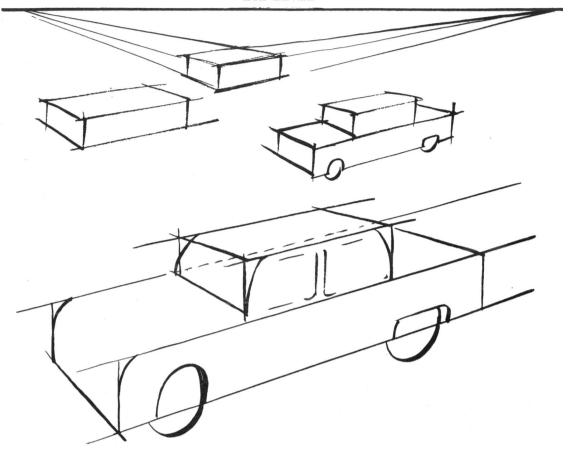

By placing one box over another and rounding the edges you have the basic perspective of a car.

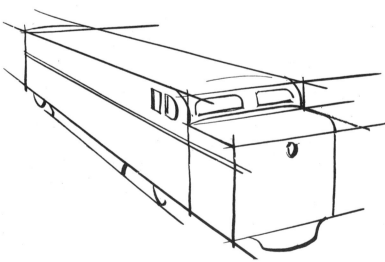

SMALL BOX placed in front of long box gives you a locomotive in perspective.

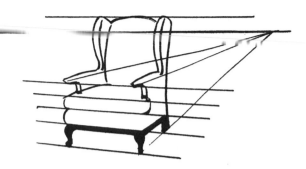

EYE LEVEL

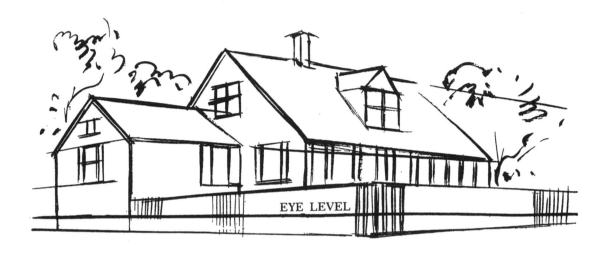

EYE LEVEL

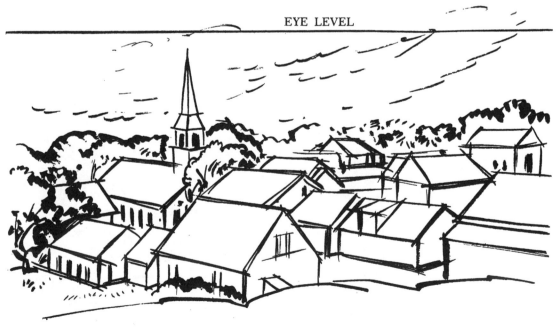

EYE LEVEL

11

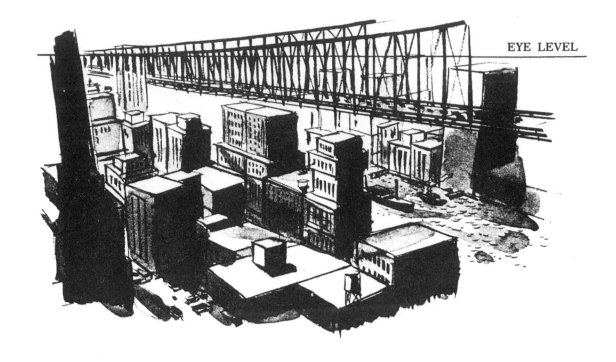

EYE LEVEL

EYE LEVEL

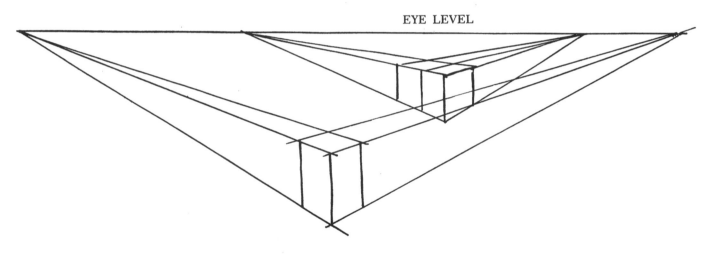

The photographs on this and the following pages are of two shipping departments filled with cartons. With the simple rule of perspective they are turned into two cities.

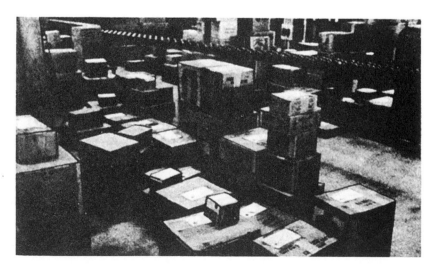

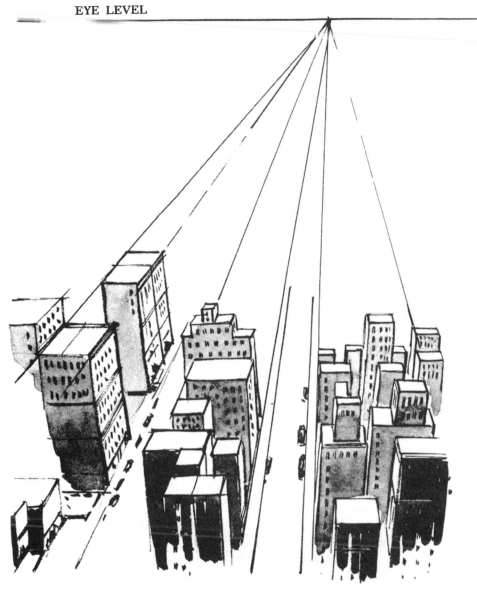

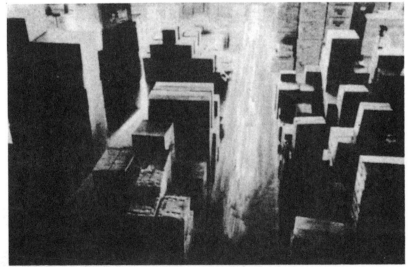

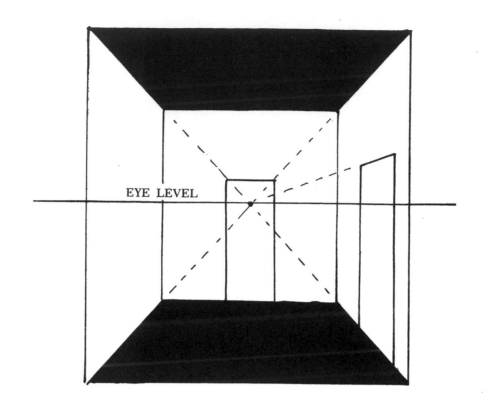

EYE LEVEL

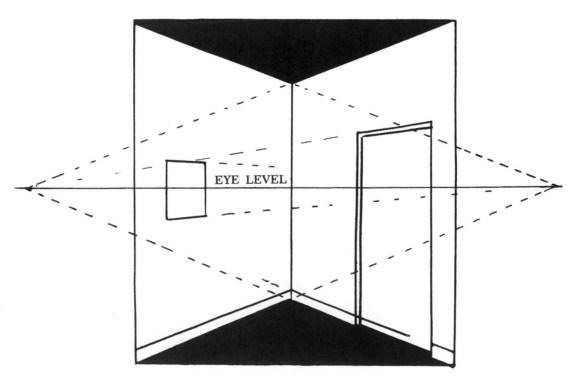

EYE LEVEL

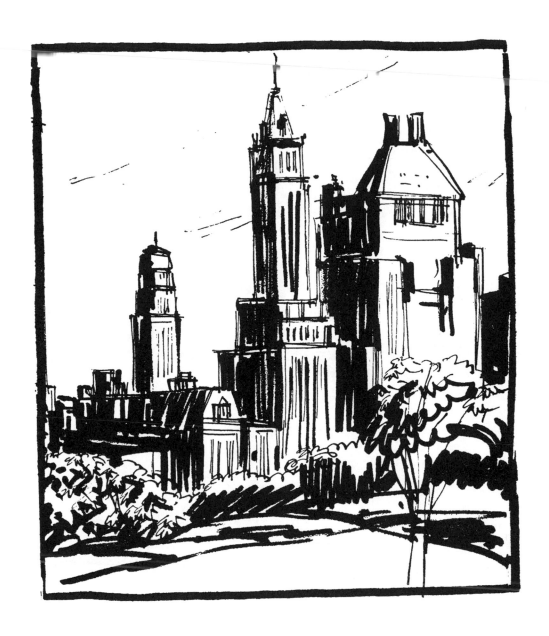

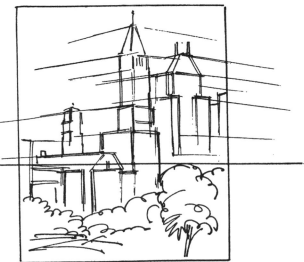

EYE LEVEL

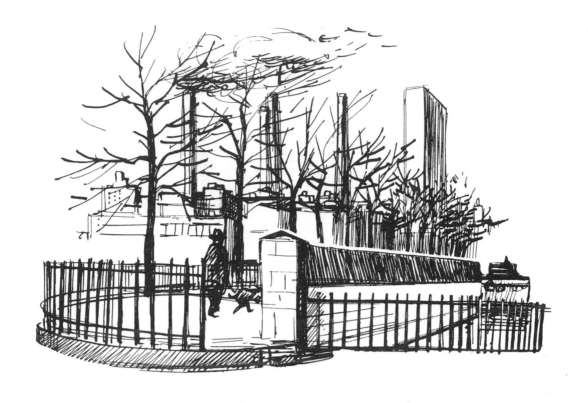

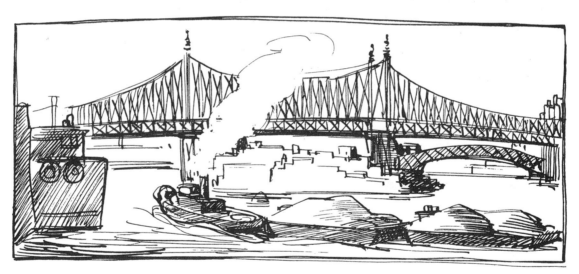

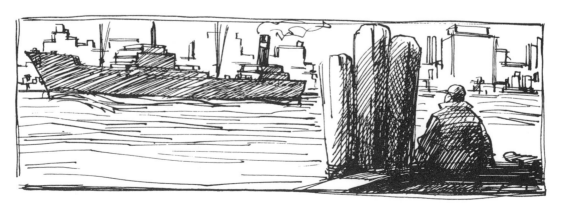

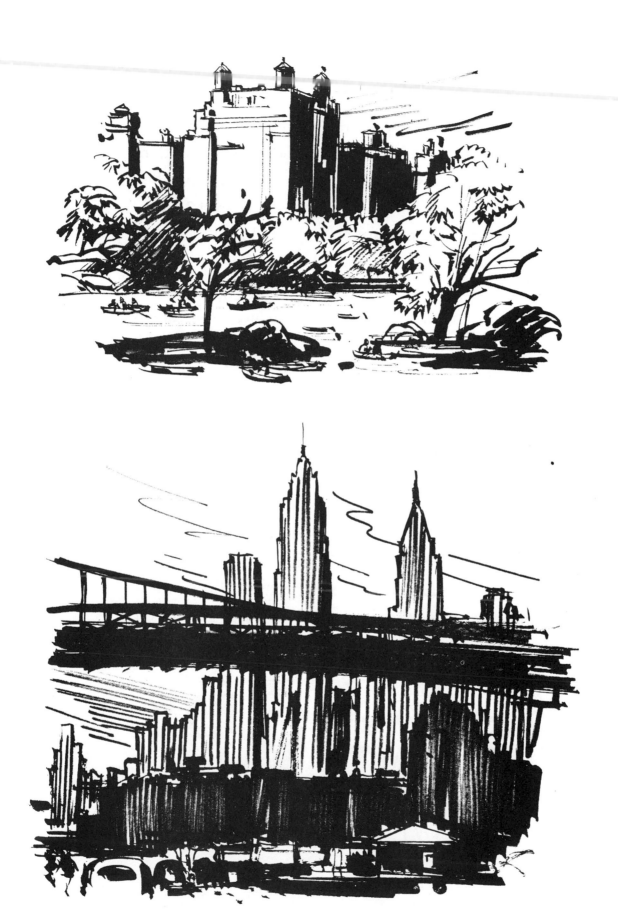

FIGURE IN PERSPECTIVE

In producing a picture with more than one figure, it is necessary to know how the figures in the background diminish in size. This is called the perspective of diminution. When you look at a string of telephone poles, the one farthest away appears smaller than the one nearest to you, even though all the poles are of the same length. Page 20 shows simple examples of how this rule of perspective is applied. On No. 1 the eye level is at the skaters' knees. The parts of the figure that are above the eye level come down to the eye level and the parts of the figure below the eye level come to the same point on the eye level. Figures A and B are of the same height because they are the same distance from C.

In figure two the eye level is at the chest of the models and in figure three the eye level is at their heads.

Page 21 shows the same rule that was applied to the box in one and two point perspective as applied to the figure. Each upright on the square is substituted by a figure. In drawing a group of figures you must first establish an eye level and must recede in perspective down to a point on this level.

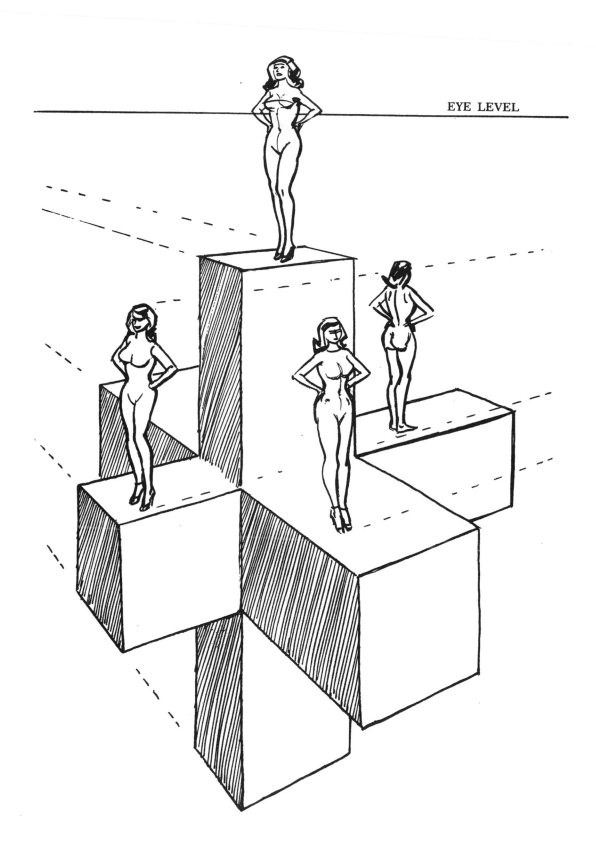

EYE LEVEL

19

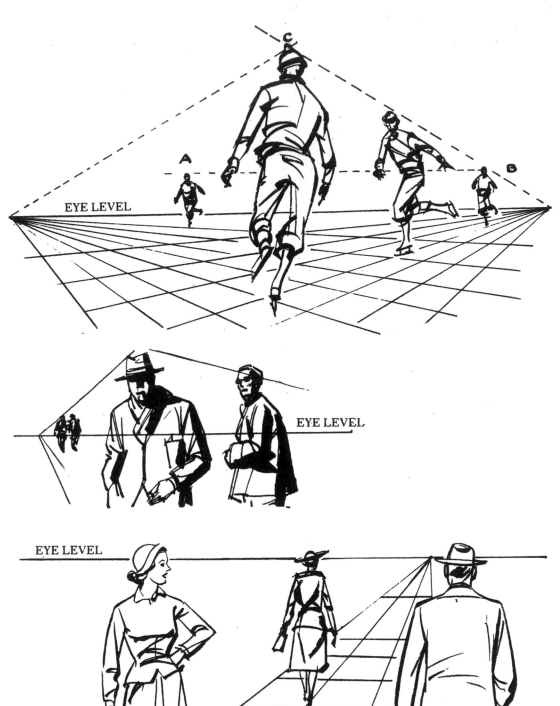

EYE LEVEL

EYE LEVEL

EYE LEVEL

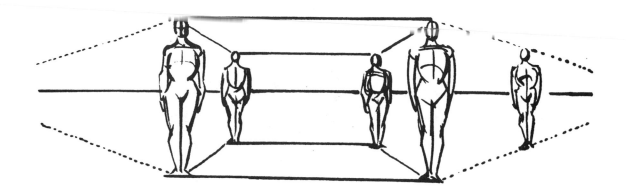

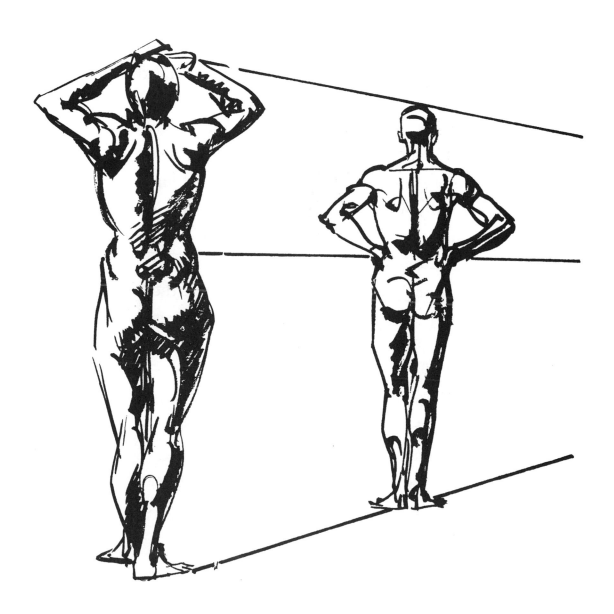

ANATOMY

To depend upon your eye to draw the human figure is a mistake. Regardless of how many drawings you might make in this manner, you will be constantly groping for knowledge. Year after year, sketch classes are filled by the same students trying to learn by this hit and miss method. Only when you try to learn how the human figure is constructed, does your ability to draw the human figure increase.

First you must learn the large simple concepts of the figure—the head, chest and pelvis—to recognize in what position they are when drawing from the figure. The head should be thought of as being a square, a cube having six sides—front and back of the head, top and bottom and two sides. The second large mass is the chest, its concept being round. The third large mass is the pelvic region (or hips) which is a square, also with six sides, back, front, two sides, bottom where the legs connect to the body, and on top where the chest is attached. These three major forms do not break but can be in different positions. Attached to these three large masses are the arms, legs, neck and abdominal muscles. These can all twist, bend and turn.

In the first pages on anatomy, you will see these concepts in various positions. At first make drawings using this concept. Of course, a knowledge of perspective is necessary in order to put the figure in different positions.

After you have made the preceding drawings, you may go on to the following pages where I've shown structures of the forms starting with the head.

When starting a figure drawing, first mark the length of your drawing from the top of the head to the bottom of the feet. This is to avoid amputation of the figure by starting on top and hoping to get all of the figure on the page. Drawing at random is a bad practice and results in bad amputation of the figure. After marking the top and bottom of the figure, block in the head. Then establish the pit of the neck. Make a curved line showing direction of the chest, and then continue that line through the abdomen to the crotch. The crotch can be regarded as the half-way mark in the figure. This system will also apply to the back, using the spine as the action line.

In shading your drawing, first, keep in mind the large masses. At the beginning, keep them simple as possible. Try to use as few tones as possible and remember, that all the shading in the world will not make a bad drawing good.

The drawing of the figure should not be just a series of bumps and shading. A student learns only when he questions the shape and function of each muscle. Only then can he use anatomy creatively.

A famous anatomy teacher of mine at the Art Students League once said, "I've given fifty years of my life to prove and teach that a varicose vein is not a muscle." From that day on I started to learn something about the human figure.

FIGURE MEASUREMENT

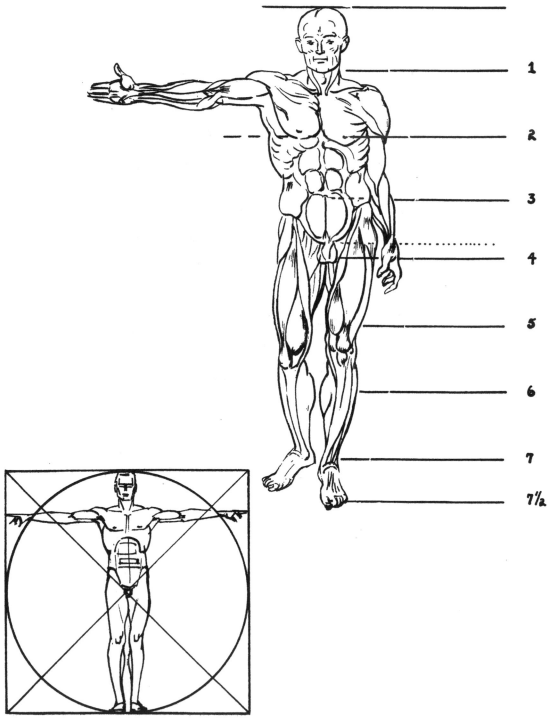

1

2

3

4

5

6

7

7½

Foreshortening can be easily understood by putting the three large masses (head, chest, pelvis) in position and then reducing arms and legs to simple stove pipe forms.

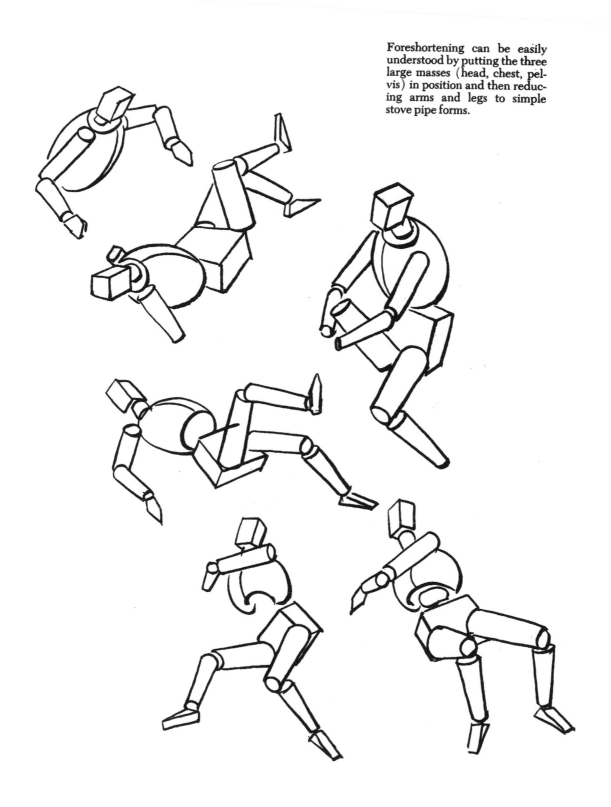

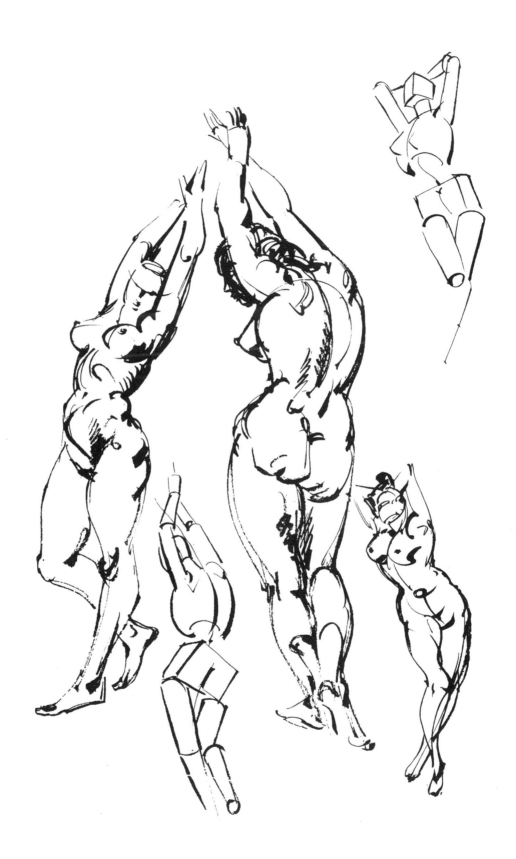

26

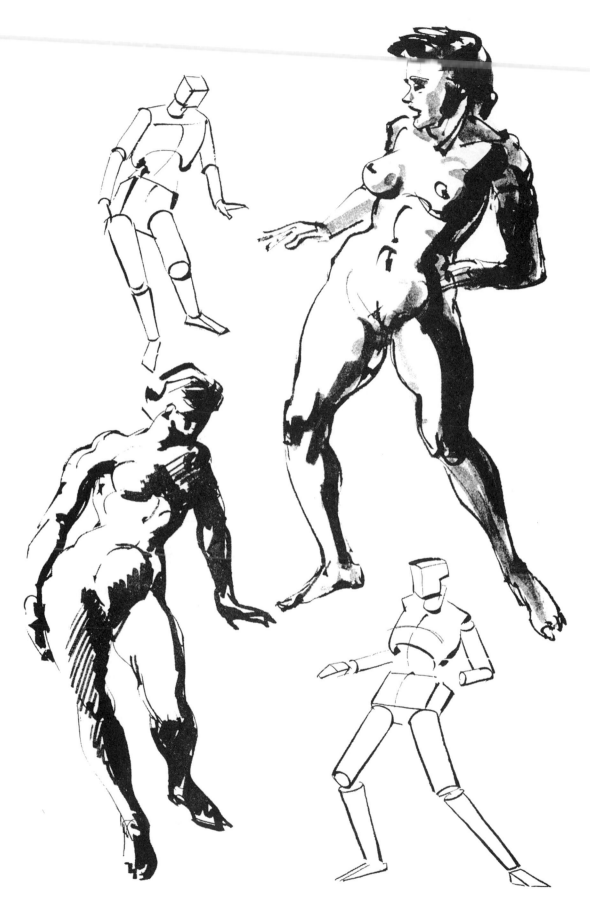

27

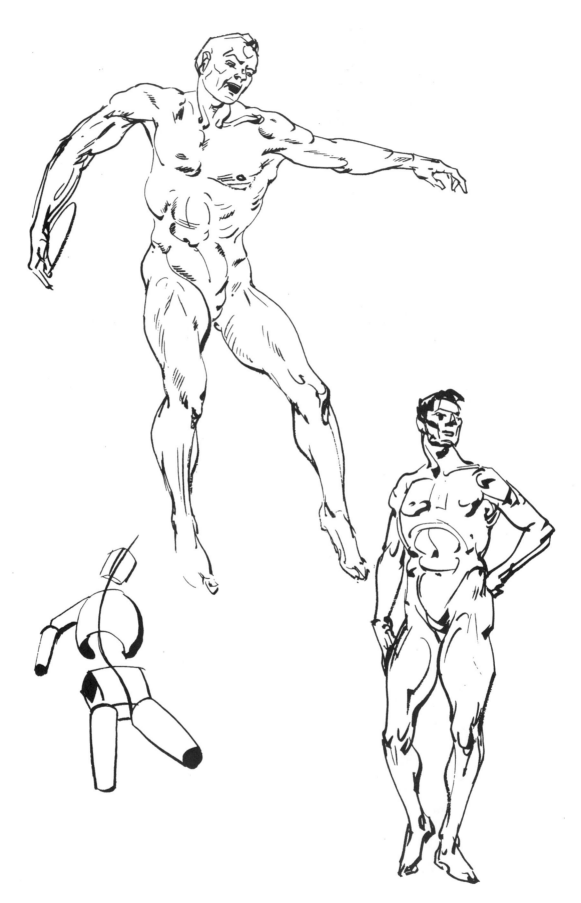

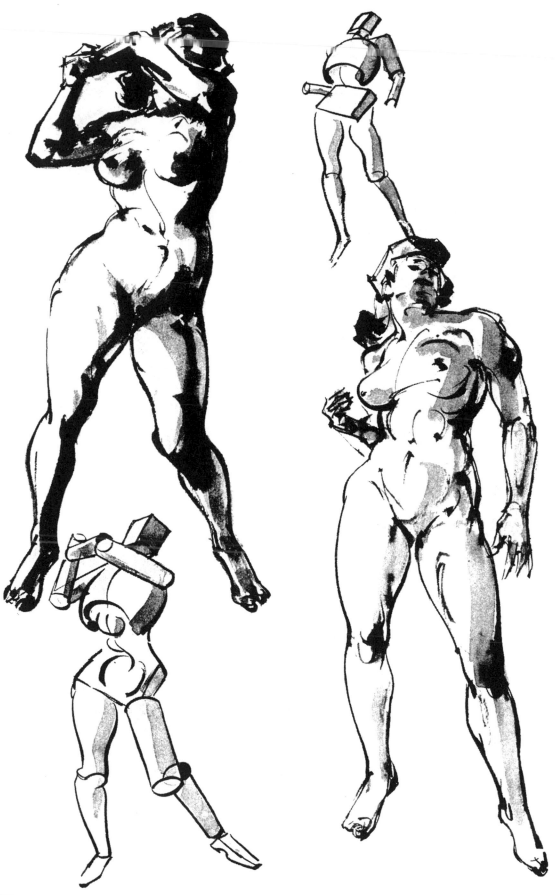

29

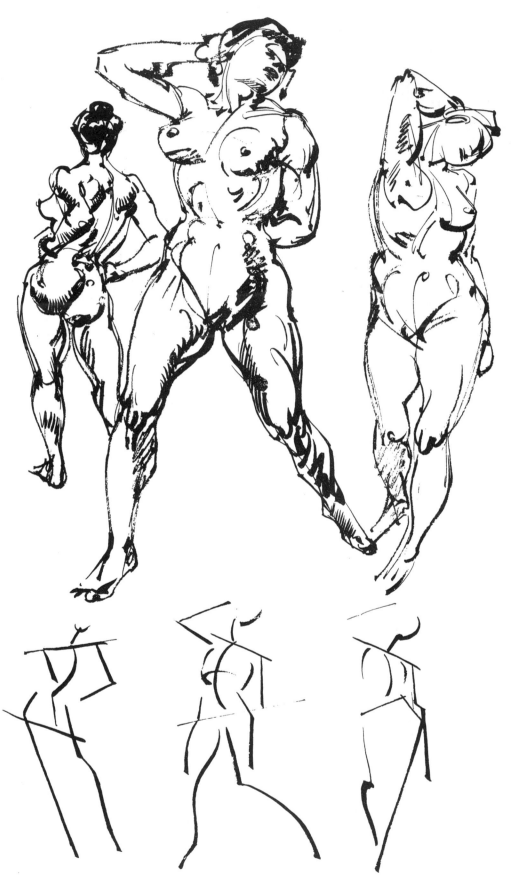

Try reducing the following figure drawings to the simple concept previously explained. Use the three large masses, head, chest and pelvis and pipe forms of arms and legs, to show fore-shortening and direction. If this is understood, the following anatomical explanations will be learned much easier.

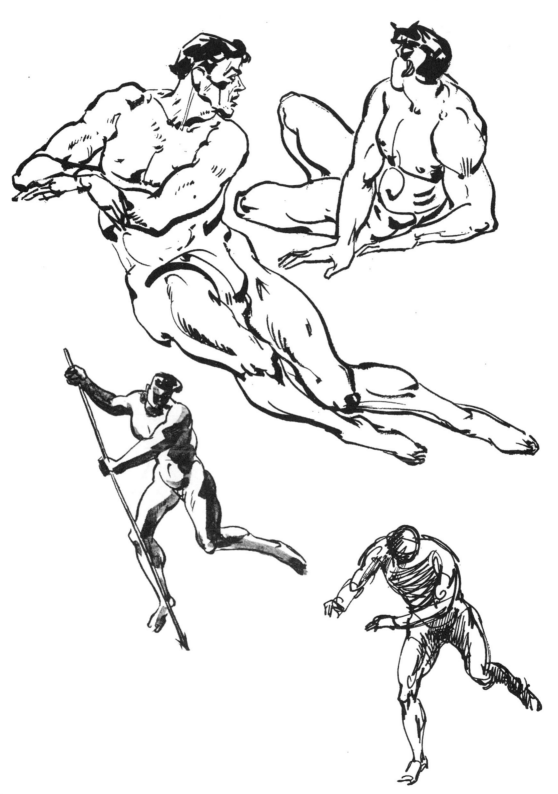

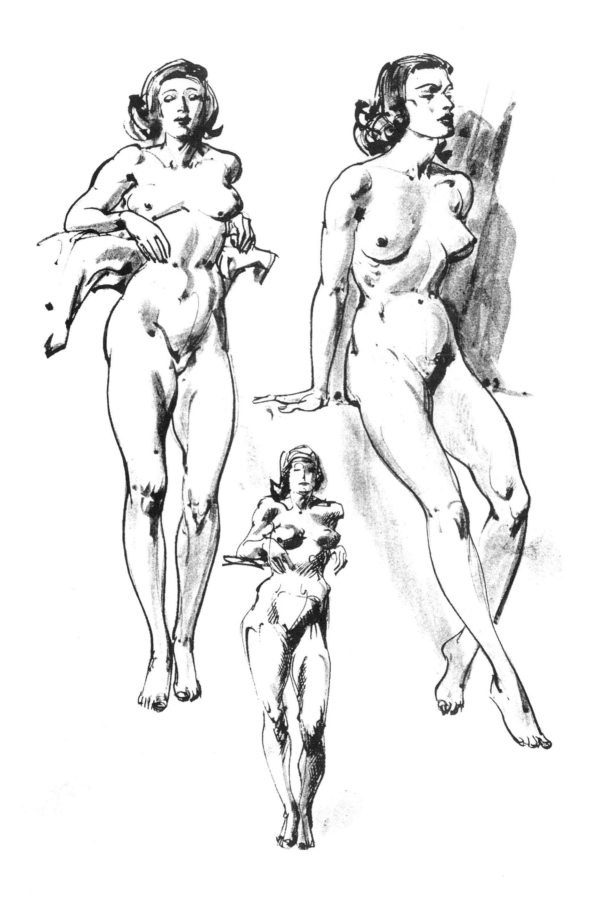

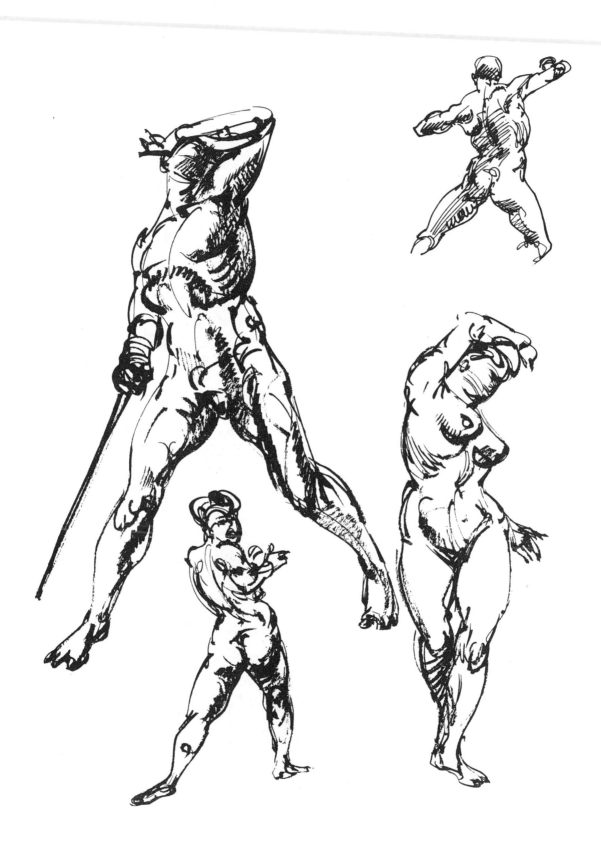

33

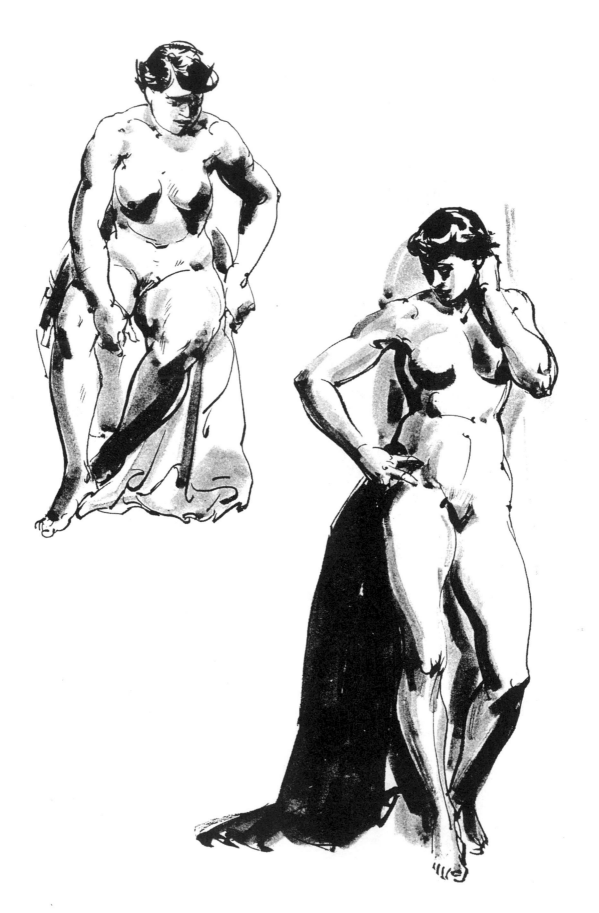

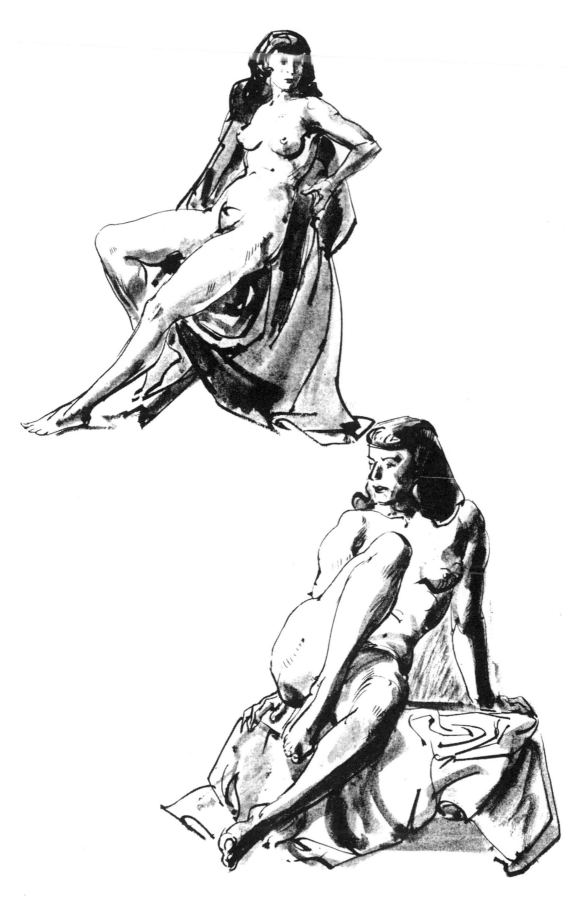

35

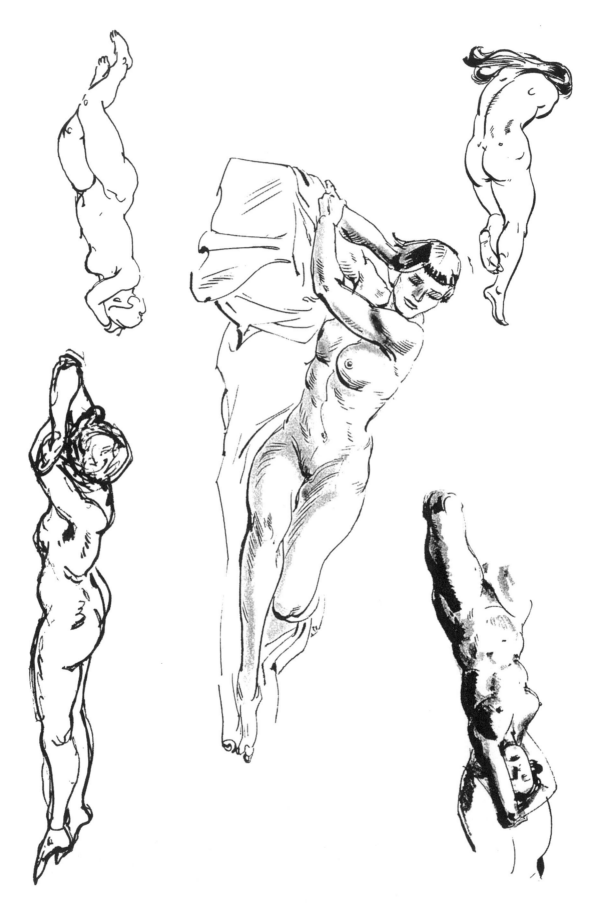

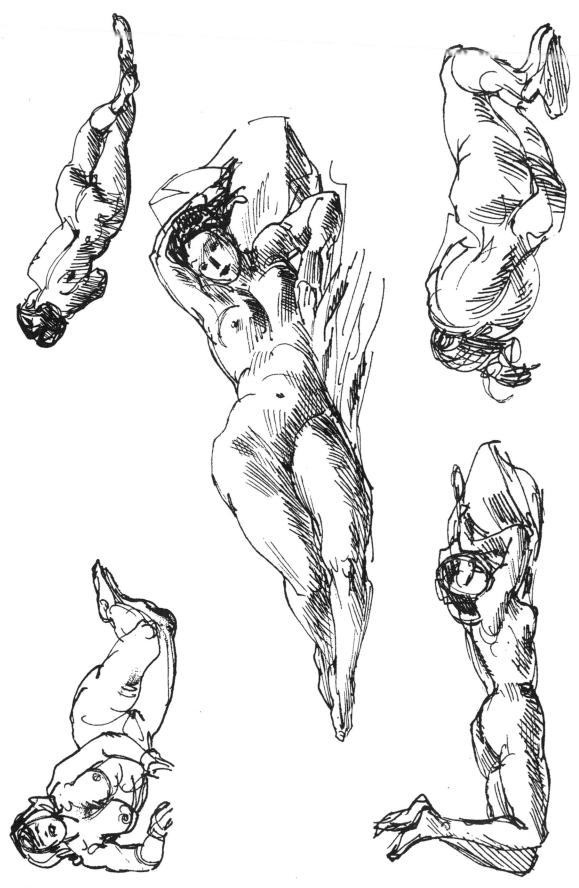

37

FIGURE IN MOVEMENT

The human figure is capable of twisting, bending and moving in an incalculable number of positions. A concept of the three large masses of the head, chest and pelvis must be understood in order to place these masses twisting in front or turning away from each other, or covering each other as in foreshortening.

Think of the head being square. The chest is round and about one and a half times as long as the head and twice the width. The pelvis is square and also twice the width of the head. Keep the same distance between the chest and the hip as between the head and the chest.

The three masses are attached to each other at the back of the figure by the spinal column and in front by muscles, tendons and ligaments.

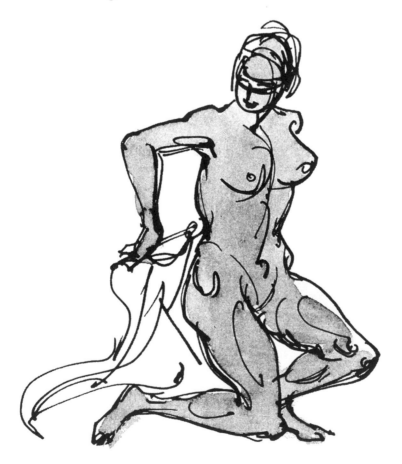

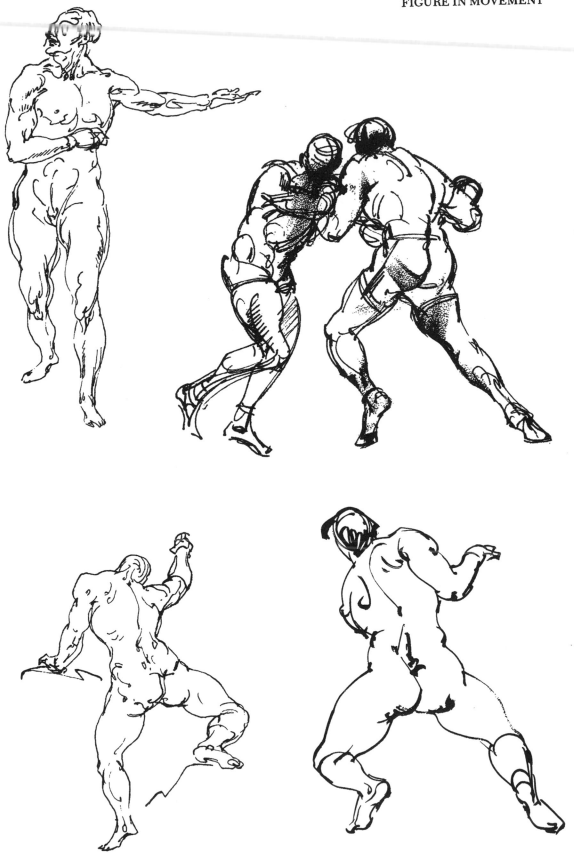

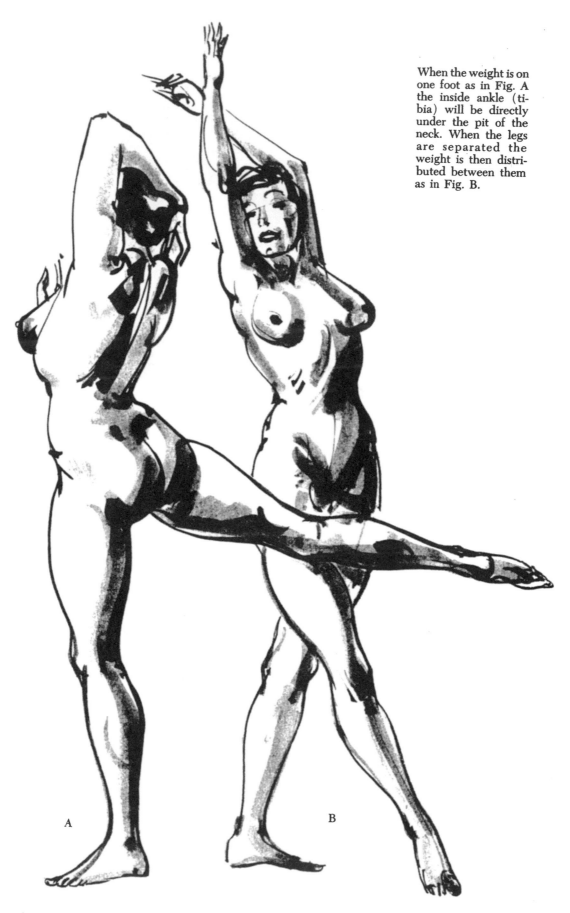

When the weight is on one foot as in Fig. A the inside ankle (tibia) will be directly under the pit of the neck. When the legs are separated the weight is then distributed between them as in Fig. B.

A

B

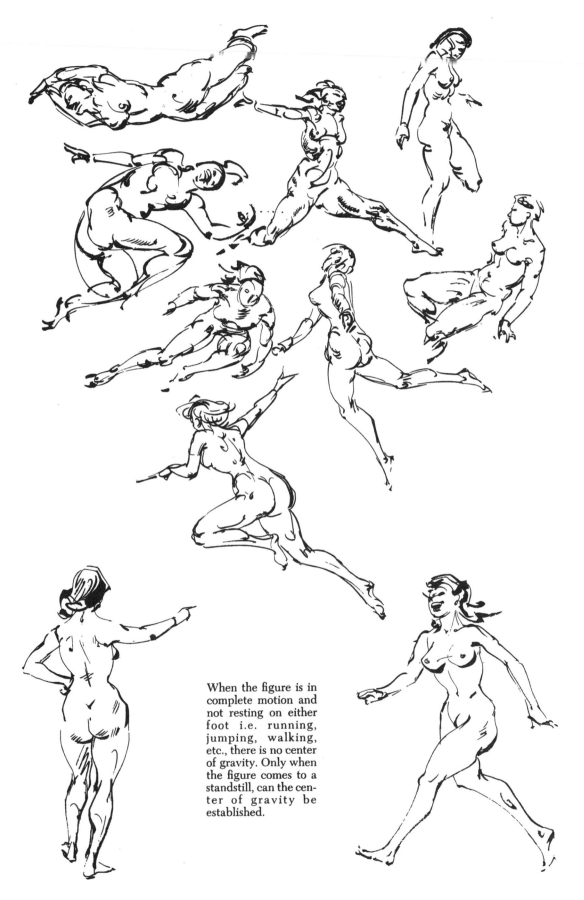

When the figure is in complete motion and not resting on either foot i.e. running, jumping, walking, etc., there is no center of gravity. Only when the figure comes to a standstill, can the center of gravity be established.

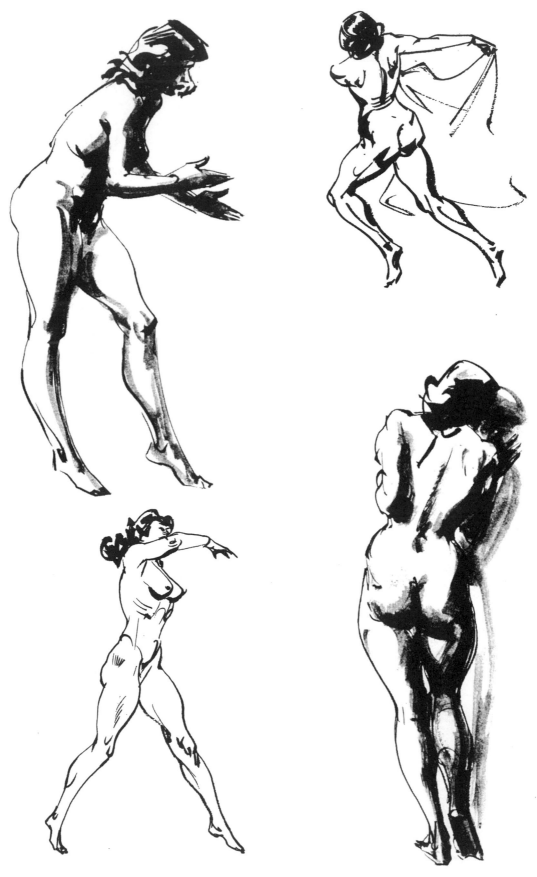

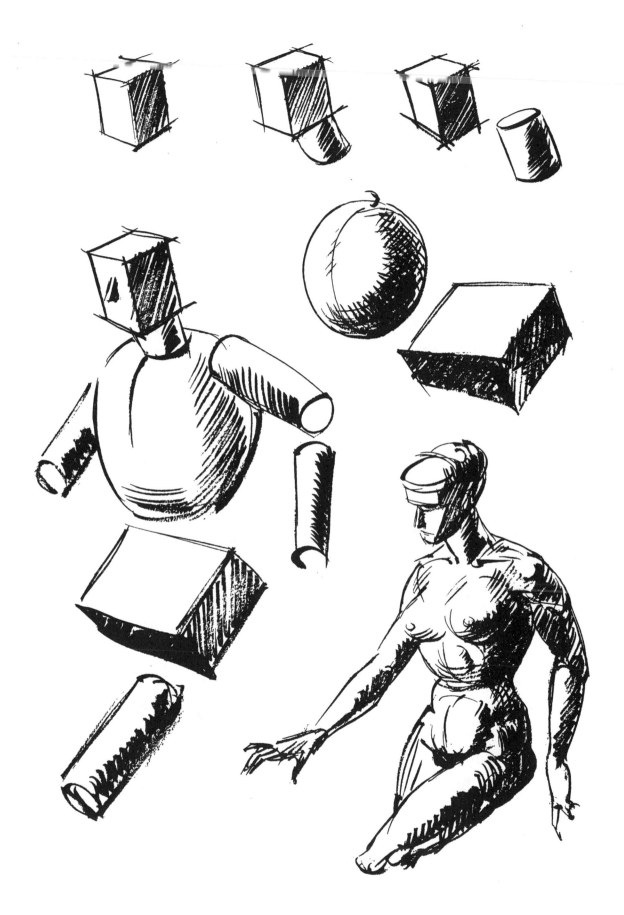

THE HEAD

You can better understand the head in perspective by thinking of it as having six sides and being cube-like in structure. A cube establishes the front, side, bottom and top of the head quickly. After you can draw a cube in any position in perspective, then learn the bone structure and shape of the head and you will be able to place it in whatever position you choose.

The modeling of a head in light and shade becomes easier with the major planes established.

On the front of the face, keep the forehead square, the cheek bones flat, the area under the nose and around the mouth round, and the jaw triangular.

Here's a simple way to place the features accurately when drawing a head. First draw a vertical line down the middle of the face. Then draw a horizontal line halfway between the top of the head and the bottom of the jaw, on which to align the position of the eyes. Halfway between the eyes and the chin place the base of the nose; and halfway between the base of the nose and the chin place the center line of the mouth. Remember the space between the eyes is the same as the length of another eye. The length of the ear is the same as the distance between the top of the eye and the base of the nose. The width of the mouth will correspond with the distance between the eyes when they are focused straight ahead.

While the length, breadth and thickness of features may vary on different people, it is important to have a basis from which to start.

When drawing the entire figure, first establish the size of the head in order to proportion the rest of the figure to its size.

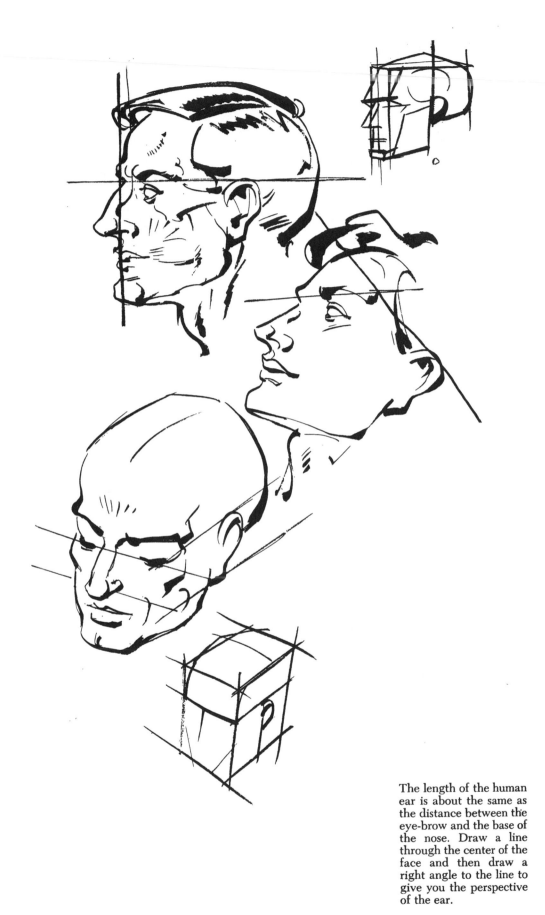

The length of the human ear is about the same as the distance between the eye-brow and the base of the nose. Draw a line through the center of the face and then draw a right angle to the line to give you the perspective of the ear.

If drawing the head in profile you can see under the nose, the head is above your eye level, or is tilted back. When the head is turned down, the line across the front of the face and the side will go up to the eye level.

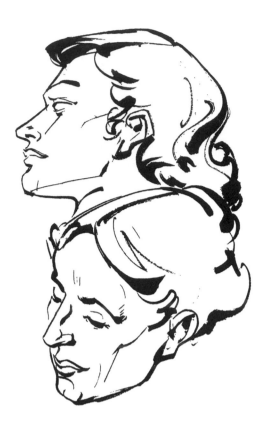

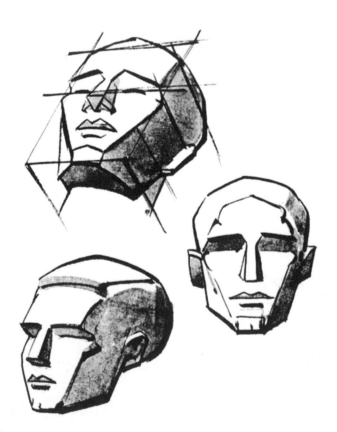

46

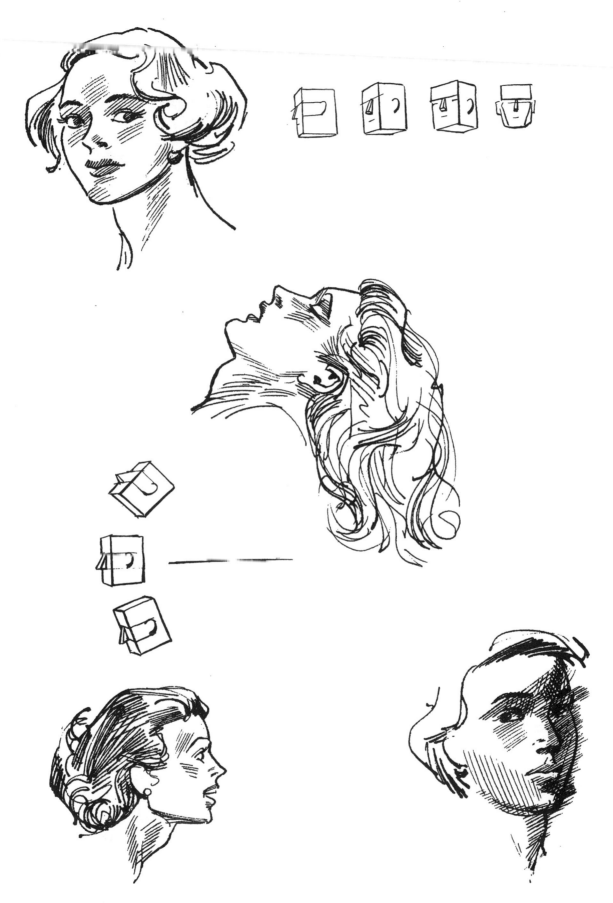

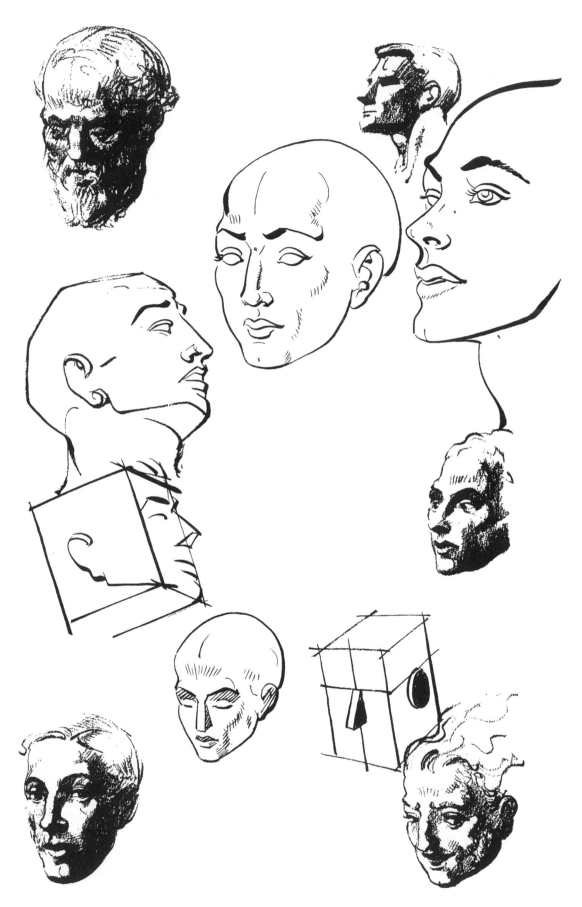

48

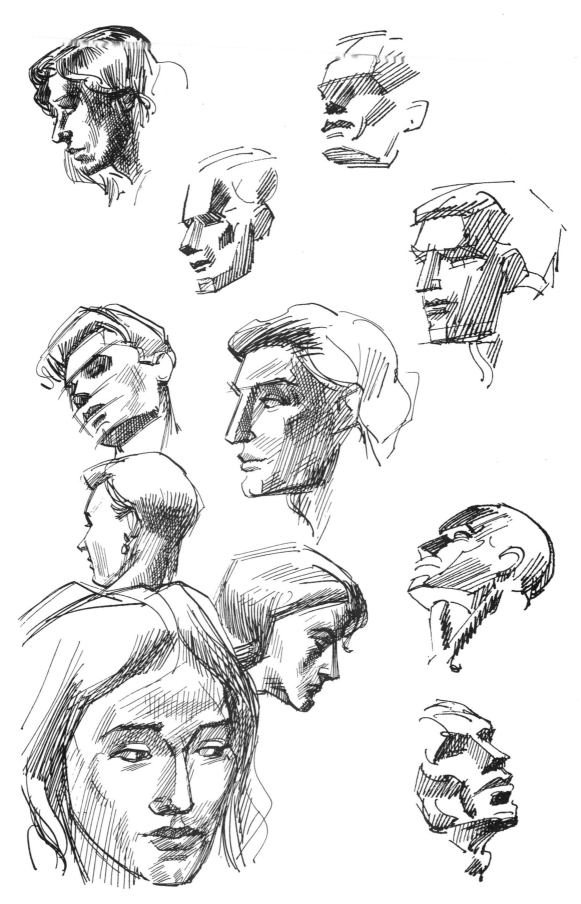

49

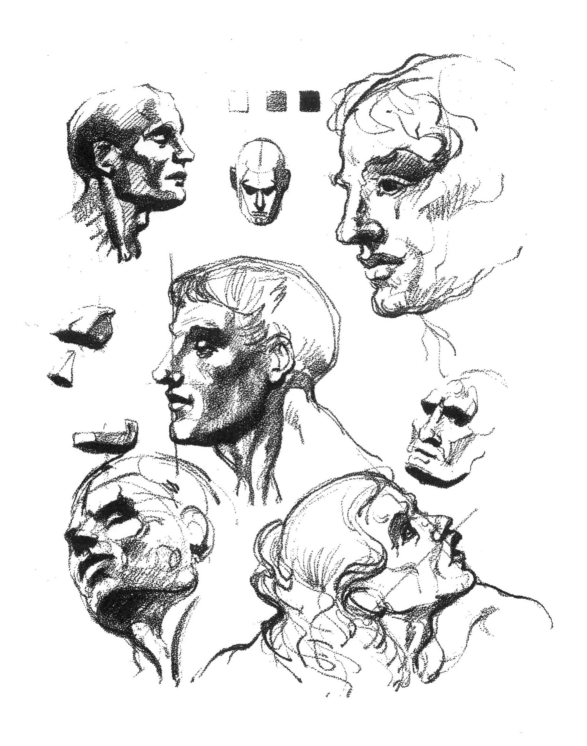

Shade the head with the idea of giving your drawing an illusion
of solidity. At first use as few tones as possible. Start with three
simple planes: light, medium and dark. The planes facing the
light are white, the side planes are a medium tone, and all under-
neath planes are dark. After this is well understood you may
proceed with as many tones as you wish, trying at no time to
lose the three tones you start with. Remember, all the shading
in the world will not improve a bad drawing.

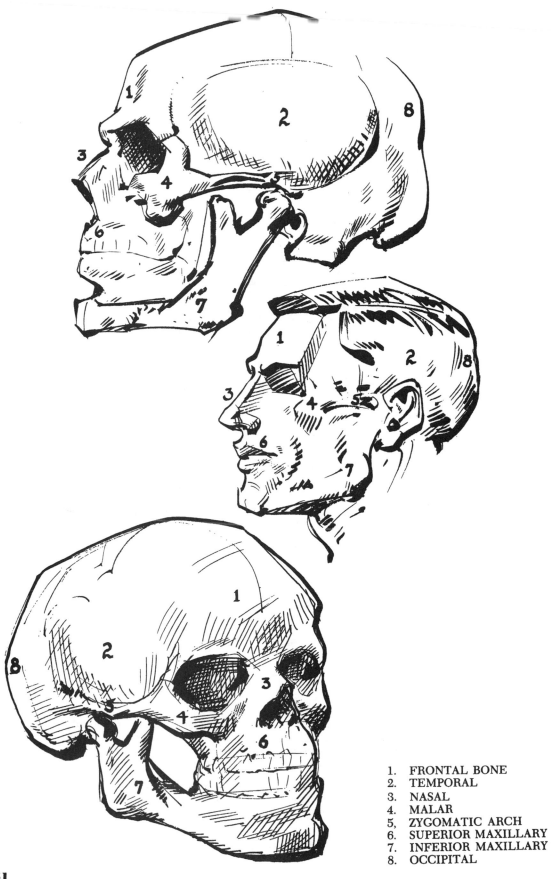

1. FRONTAL BONE
2. TEMPORAL
3. NASAL
4. MALAR
5. ZYGOMATIC ARCH
6. SUPERIOR MAXILLARY
7. INFERIOR MAXILLARY
8. OCCIPITAL

MOVEMENT OF LOWER JAW

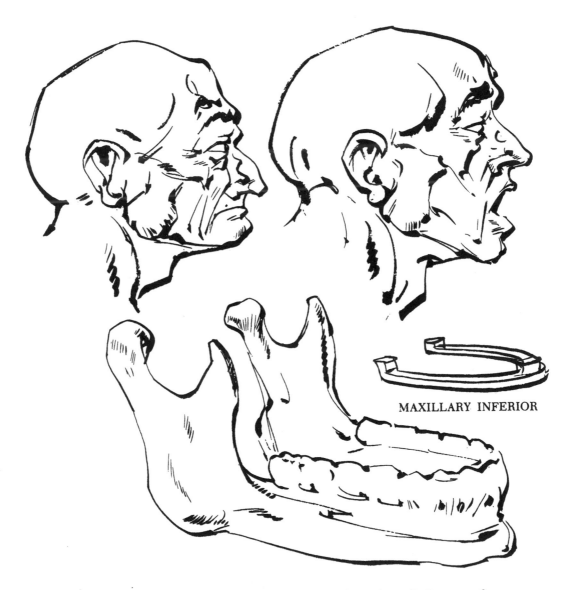

MAXILLARY INFERIOR

The only movable bone of the head is the jawbone (Inferior maxillary). The two knob-like heads fit into sockets in the temporal part of the skull just behind the entrances to the eardrums. The flat, pointed ends in front of the knobs slide under the Zygomatic arch.

The large muscle called the masseter controls the mastication and grinding of food. The masseter is attached from under the Zygomatic arch to the end of the lower jaw.

The temporal muscle raises and lowers the jaw. It comes from the temporal part of the skull to the top ridge of the Inferior maxillary.

The muscles that control the mouth are called the Buccinators (cheek muscles) and the muscles of expression are called lesser and greater Zygomatics. They are connected from the Zygomatic arch down to the circular ring of cartilage surrounding the mouth.

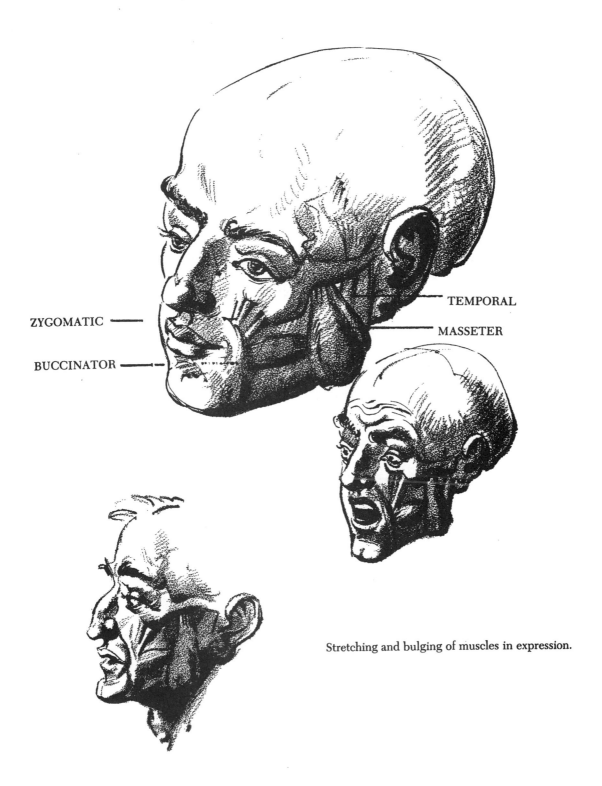

ZYGOMATIC ————

BUCCINATOR ————

TEMPORAL

MASSETER

Stretching and bulging of muscles in expression.

FEATURES

The features are the parts of the face that give it expression. When they are immobile the face is blank and expressionless. The features normally express what the brain is thinking. It is important to know their structure in order to best express the emotions of the figure. A great deal of time is spent by students of the drama learning how to transmit to the audience the character of the role they are playing. Many times the features convey quickly what would take a great many words to explain.

Facial expression plays an important part in the fine and commercial arts. Michelangelo said a great deal with the expressions on the faces of both his sculpture and painting.

The sale of products in commercial art depends a great deal upon the expression of people handling, using or eating them in advertisements. Man uses his features as a method of communication every day of his life.

A nose is not just a blob put on a face, a mouth not just an opening and eyes not just two dots, each feature has a basic structure. Learning their shape and muscular construction will aid a great deal in your ability to create better pictures.

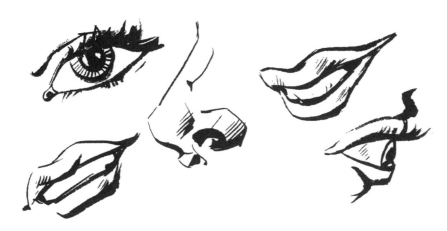

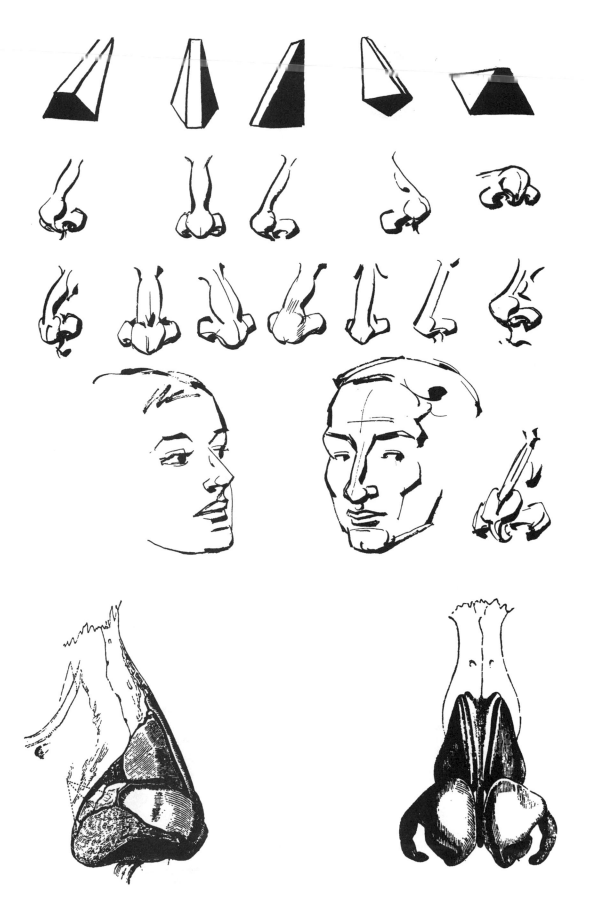

The shape of the eye is almost round. It rests in a cushioned socket of bony structure surrounding it. Four main muscles, one on top and bottom and one on each side, govern its movement. The eye projects slightly out of its socket though both lids surround the eye. The only lid that moves is the upper one. Keep the eyes apart with the length of an eye between them. On the following page is a simple explanation of the ear and mouth.

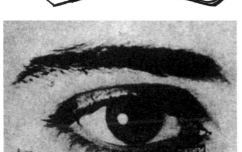

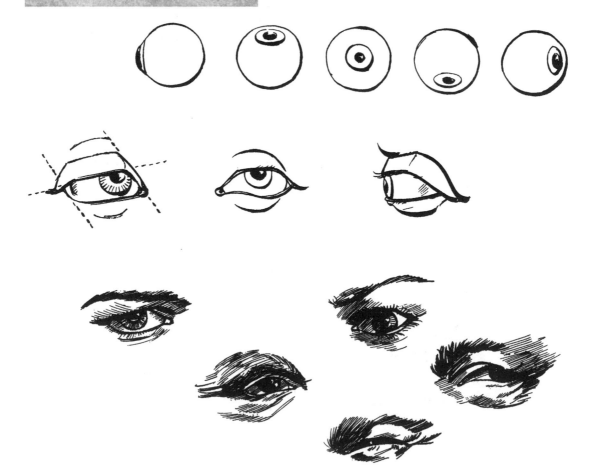

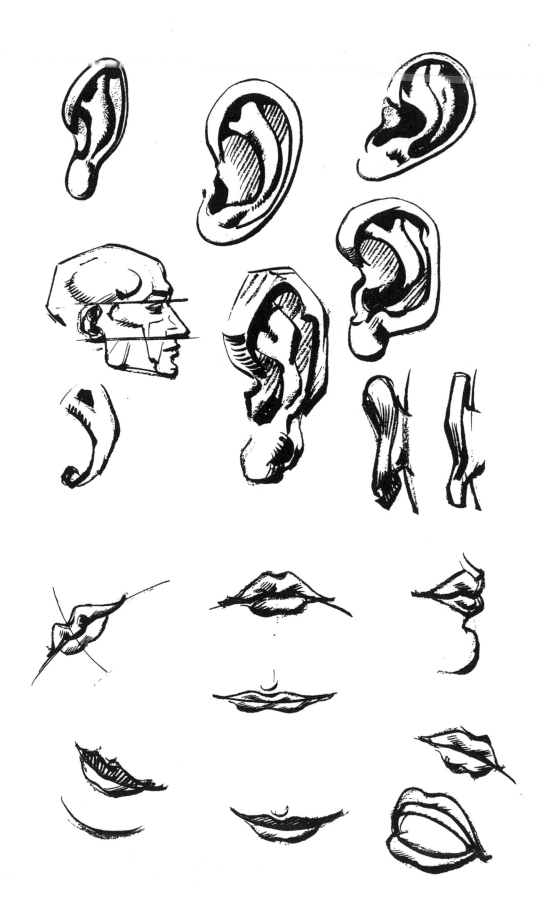

NECK

Think of the neck as being cylindrical in shape and that the top is tilted forward at all times. It starts at the end of the spinal column. Regardless of what direction or position it is in, the top of the cylinder is forward. From the mastoid part of the head (behind the ear) the mastoid muscle crosses the cylinder to the pit of the neck where it is attached to the sternum and to the clavicle.

Flat on the back of the cylinder is the trapezius which comes from the occeptal part of the head across the shoulder girdle and down the back to a point as far as the twelfth cervicle. In front, the cube-like structure coming out of the maxilliary in the male figure is called the larynx or "adams apple." These muscles all combined compose the cylinder shape first mentioned and are modelled with that concept in mind.

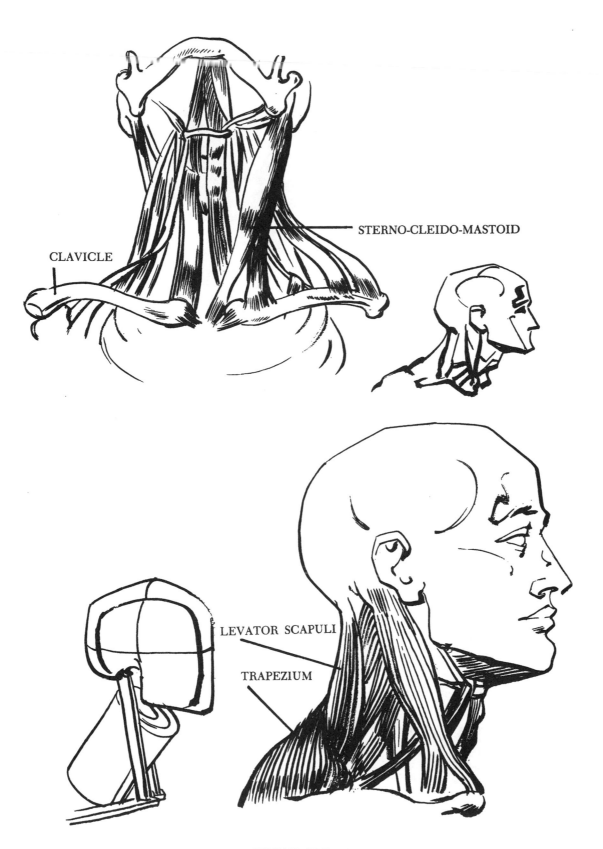

STERNO-CLEIDO-MASTOID

CLAVICLE

LEVATOR SCAPULI

TRAPEZIUM

STERNO-CLEIDO-MASTOID

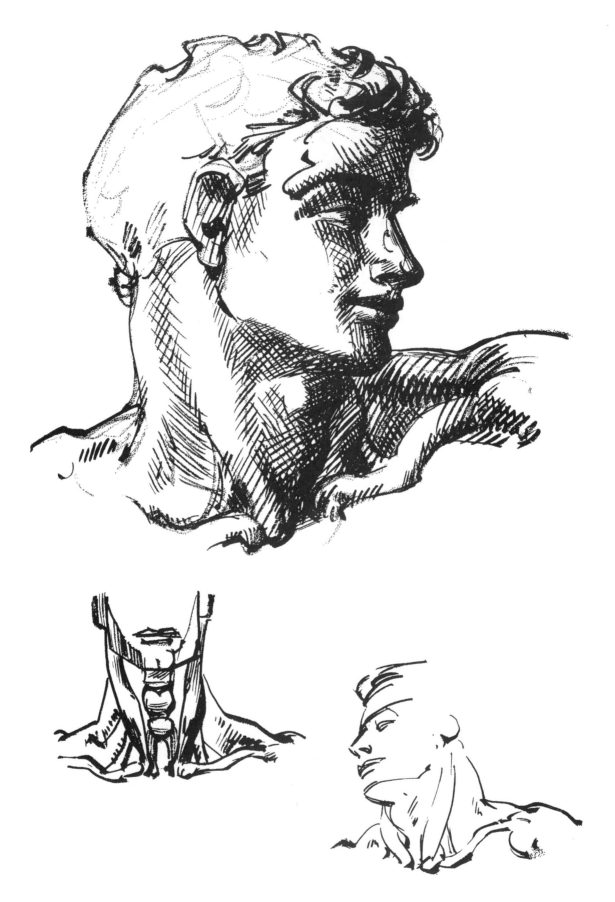

TORSO

The largest unit in the human figure is the chest, often called "the cage." It should be conceived of as being round. The bony structure of the cage consists of twenty-four ribs, twelve on each side. In the back they are attached to the spinal column from the eighth cervicle down. In front, the first seven are attached to the sternum and are referred to as the true ribs. The next three are attached to each other and are called the false ribs. The last two, attached only to the spinal column, are called the floating ribs. The ribs are flexible; they expand and contract with our breathing.

On top of the cage in front there are two large muscles, the Pectoralis minor and the Pectoralis major. The minor is underneath the major, attached from the third, fourth and fifth ribs to the clavicle. The Pectoralis major is attached from the inner half of the clavicle all along the sternum as far as the sixth and seventh ribs to the Humerus bone.

The stomach muscles, rectus abdominis, are attached from the Pubic crest up to the fifth and seventh ribs.

The Serratus magnus muscles on the side of the cage start from the upper eight ribs and are inserted into the scapulas spinal edge (the shoulder blade).

The Deltoid, which is partly seen in front, is attached to the outer end of the clavicle across the head of the humerus (upper arm bone) and across to the ridge of the scapular (shoulder blade) and to the side of the humerus about half way down. It draws the arm backward and forward.

1. PECTORALIS MINOR
2. SERRATUS MAGNUS
3. RECTUS ABDOMINIS
4. EXTERNAL OBLIQUE
5. DELTOID
6. PECTORALIS MAJOR

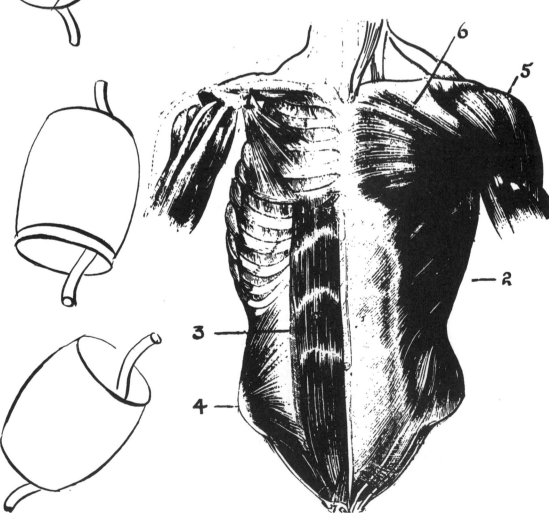

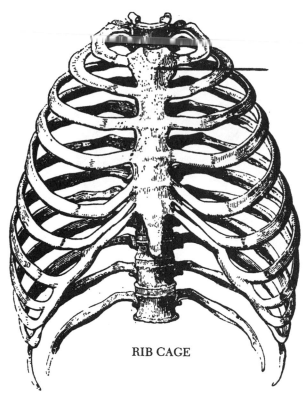

STERNUM

RIB CAGE

The dividing line between the cage is the sternum. In back of the cage is the spine. The Pectoralis minor starts from all along the sternum across to the Humerus (arm bone). When establishing the direction of the chest, use a curved line that follows the sternum and continue it to the bottom of the cage. In modelling the cage with light and shade, shade north and south as well as east and west.

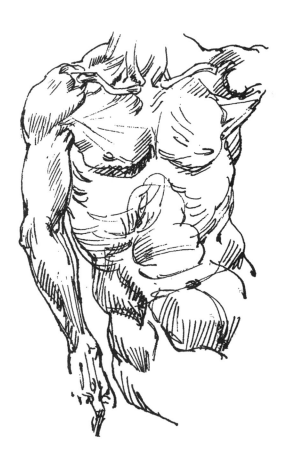

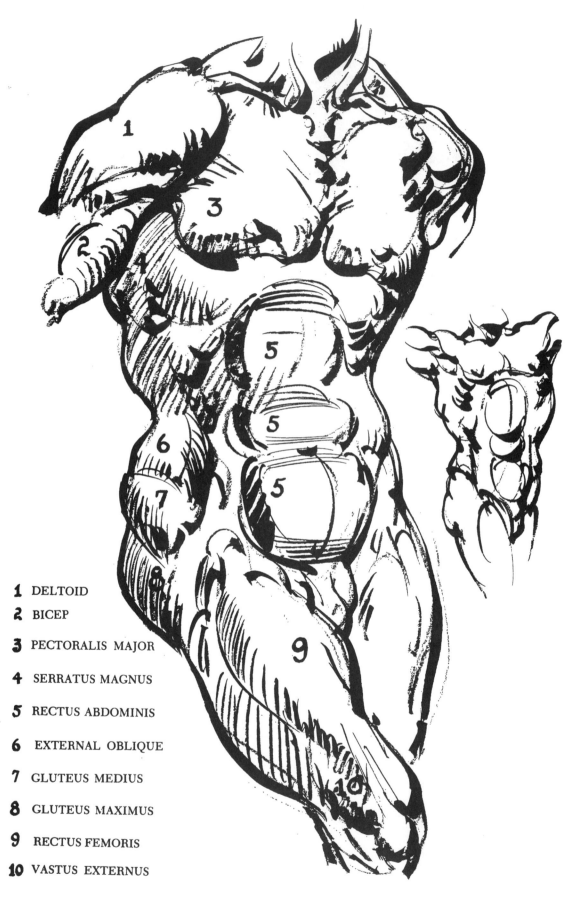

1 DELTOID

2 BICEP

3 PECTORALIS MAJOR

4 SERRATUS MAGNUS

5 RECTUS ABDOMINIS

6 EXTERNAL OBLIQUE

7 GLUTEUS MEDIUS

8 GLUTEUS MAXIMUS

9 RECTUS FEMORIS

10 VASTUS EXTERNUS

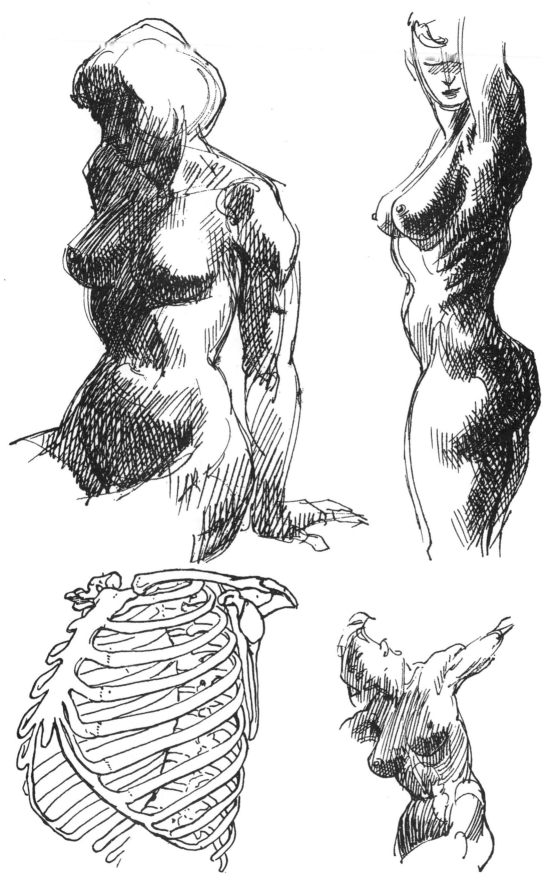

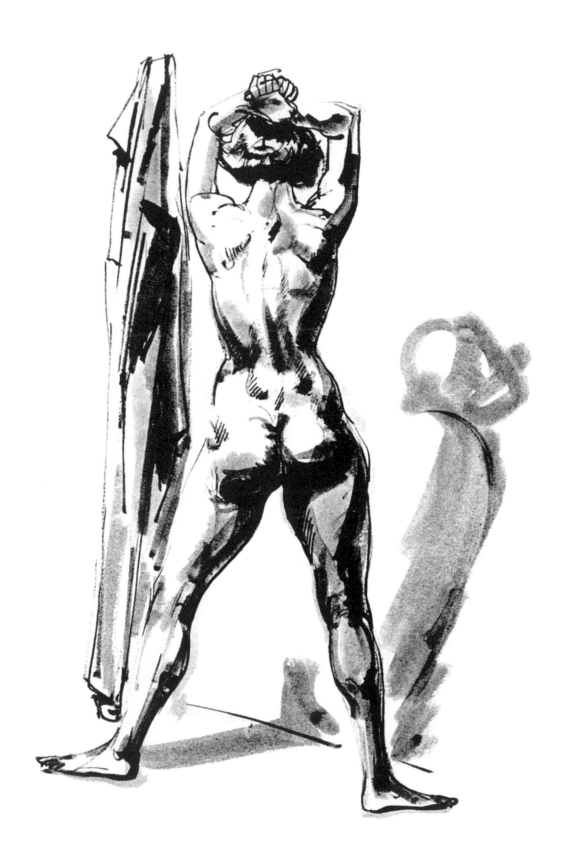

BACK.

The movement of the back is limited to the spaces between the vertebrae. In bending backward and forward the expansion or contraction occurs in the waist or lumbar region. In bending sideways there is no movement in the entire length of the spine.

With the movement of the shoulder girdle the shoulder blades rotate on the cage. There are twenty-six vertebrae composing the entire spine, the first seven belong to the neck, the eight will give you the line of the shoulders. The lower tip of the triangular shape of the shoulder blade is about half way down on the cage. In profile keep the neck concave. The back convex, the region between the end of the cage and the top of the hips concave.

After blocking in the head, suggest the line of movement with the spine and then place the cage and pelvis on it.

In modelling the back, keep in mind a concept of a large peach with a recession in the center for the vertebrae.

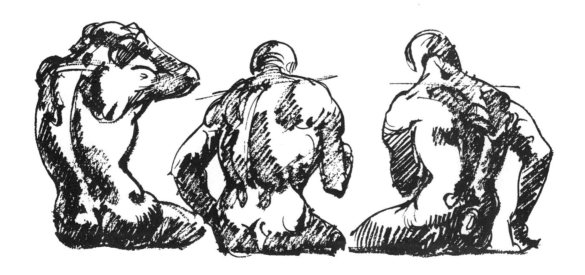

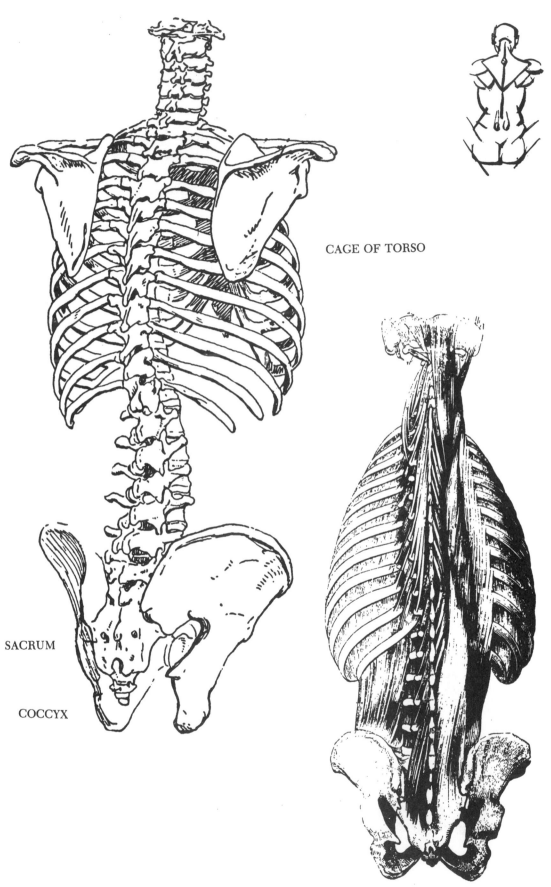

CAGE OF TORSO

SACRUM

COCCYX

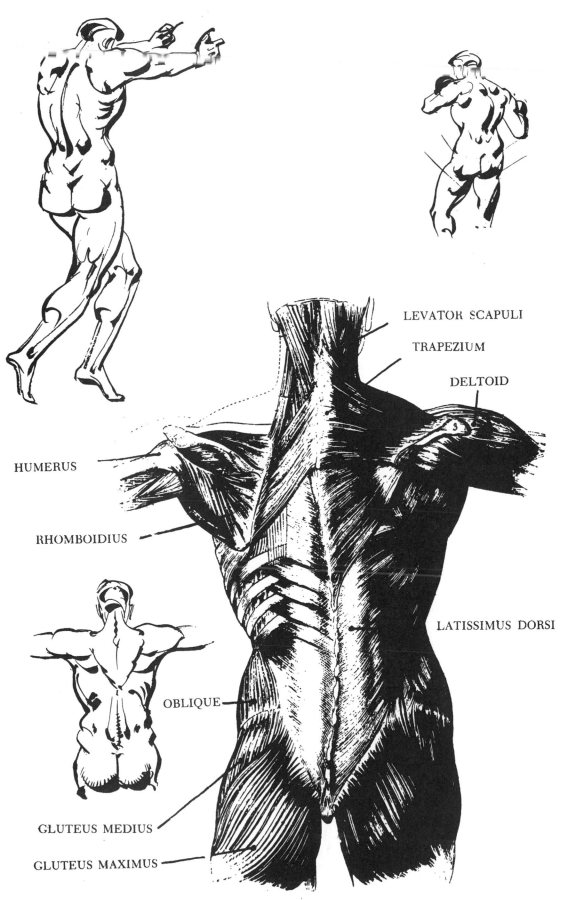

LEVATOR SCAPULI

TRAPEZIUM

DELTOID

HUMERUS

RHOMBOIDIUS

LATISSIMUS DORSI

OBLIQUE

GLUTEUS MEDIUS

GLUTEUS MAXIMUS

69

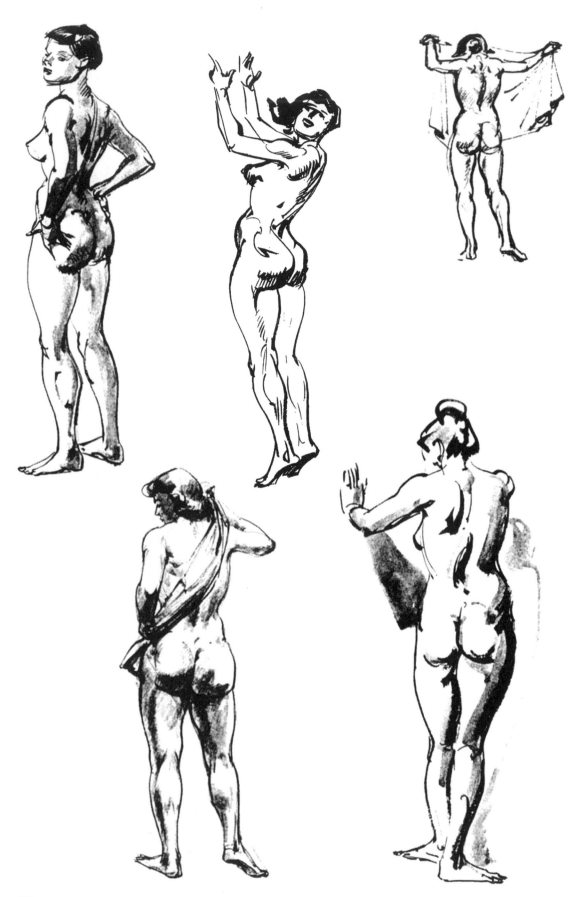

70

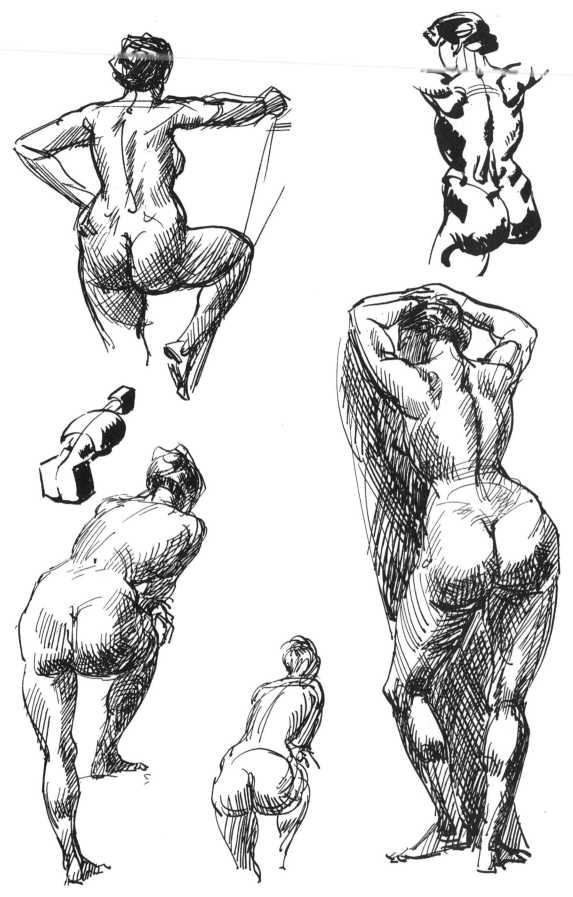

HIPS

Because of the unusual shape of the hips, a simple concept must be conceived. Like the head it is square in concept and is tilted forward. It has six planes, front, back, two side top where the cage is attached and bottom where the legs come from. The hips consist of three major bones. The Pubis, the Illium in front and the Ischium behind. The lower end of the spinal column is wedged in between both blades at the Sacrum. The hips can bend with the cage or twist opposite the cage in many positions because of the spaces in the vertebra.

The large muscle, External oblique, comes from the lower eight ribs to the Illiac crest and a ligament branches from it to the pubis. The Gluteus medius comes from the outer surface of the Illium, covering the great trochanter and to the side of the femur.

The Gluteus maximus (the part you sit on) the largest muscle of the hip comes from the rear part of the crest of the Illium, the Sacrum, the Coccyx and to the side of the Femur. Looking directly in front of the pelvis, the tensor Vaginal femoris comes from the front end of the crest of the Illium to the Facia lata on the outer side of the leg, directly in front. The Rectus femoris comes from the inferior spine of the Illium to the Patella (knee cap). The Sartorius comes from the knob in front of the Illium down along-side of the rectus to below the knee cap inside the Tibia.

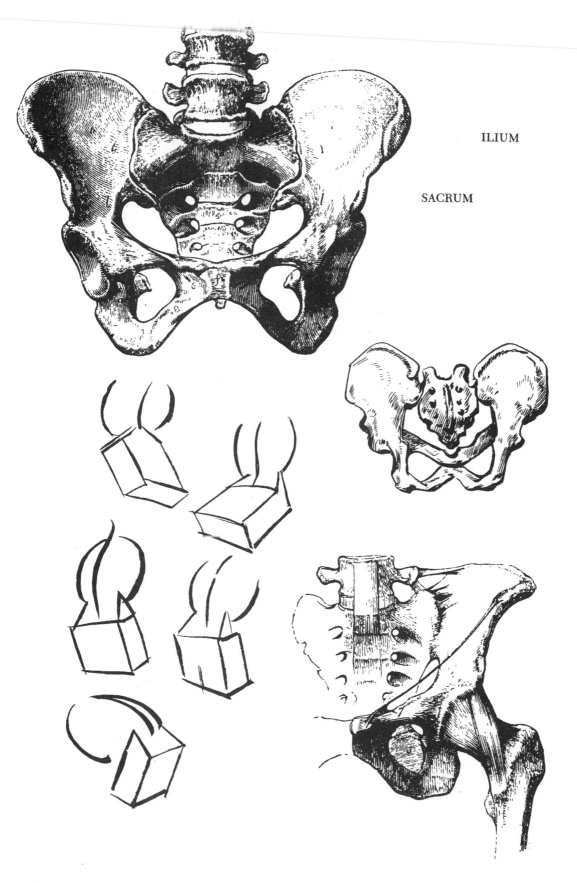

ILIUM

SACRUM

73

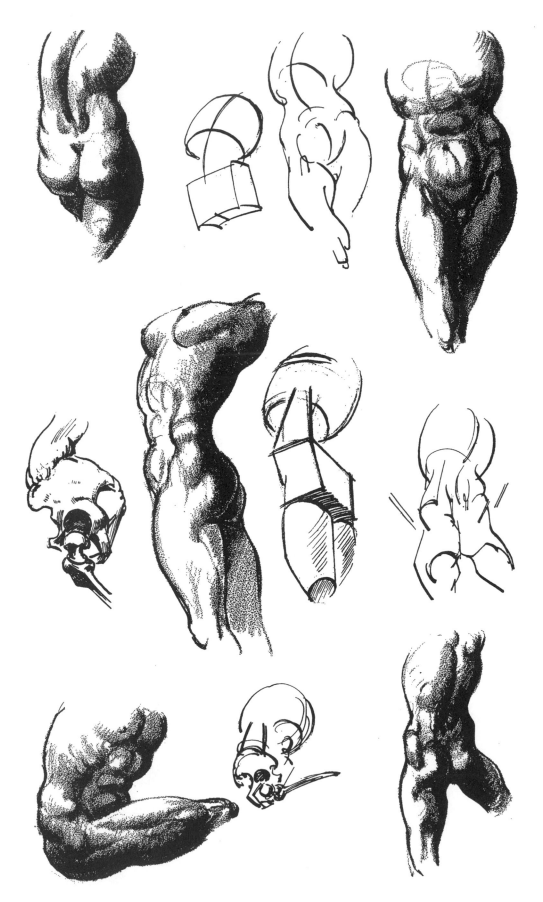

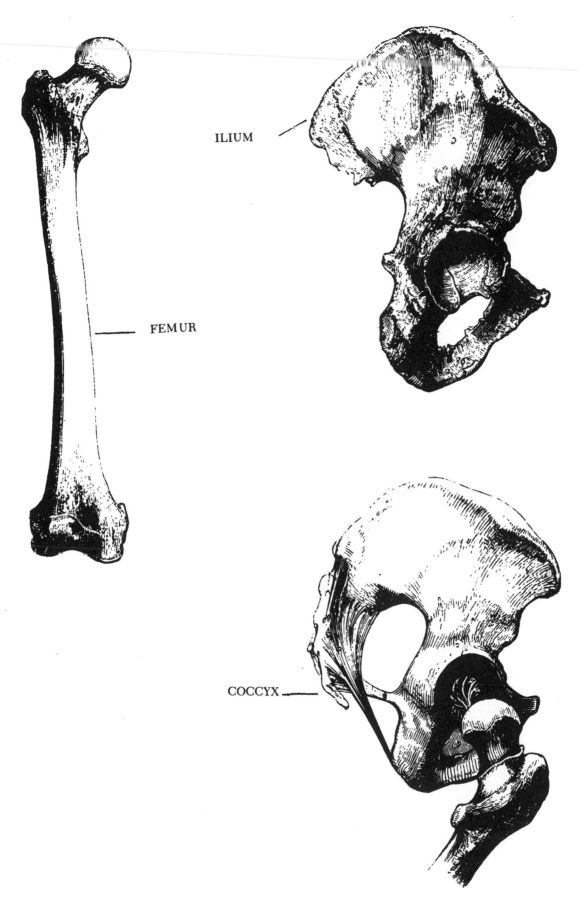

ILIUM

FEMUR

COCCYX

LEG AND FOOT

The leg and foot is divided into three parts. The thigh, leg and foot.

The bone of the thigh (Femur) the largest bone in the body is inserted into the center of the side of the pelvis. The Femur rests on the Tibia or shinbone on the outside of the Tibia is the Fibia it is lower on the foot. The Tibia rests upon the Astragalus and the Oscalsis. The Patella (knee cap) is above the level of the joint.

Muscles of the upper leg in front Rectus Femoris, Abductors, Vastus Internus and Vastus Externus. On the back of the upper leg there is the Semi tendinosus Semi Membranosus and Bicep Femoris.

Muscles of the lower leg in front. Tibialis Anticus, Peroneus Longus and Extensor Digitorium Longus.

MUSCLES OF THE LOWER LEG

Gastrocnemius and Soleus. The entire leg should have a reverse curve.

The foot is like an arch bearing the weight of the body. The inner side of the foot is above ground and the outside flat. The front of the foot has three bone sections. The Astragalus, the Metatarsals and the Phalanges (the toes). The back part of the arch is called the oscalsis or the heel bone. When learning to draw the foot, first reduce it to a simple concept in position and then draw its structure.

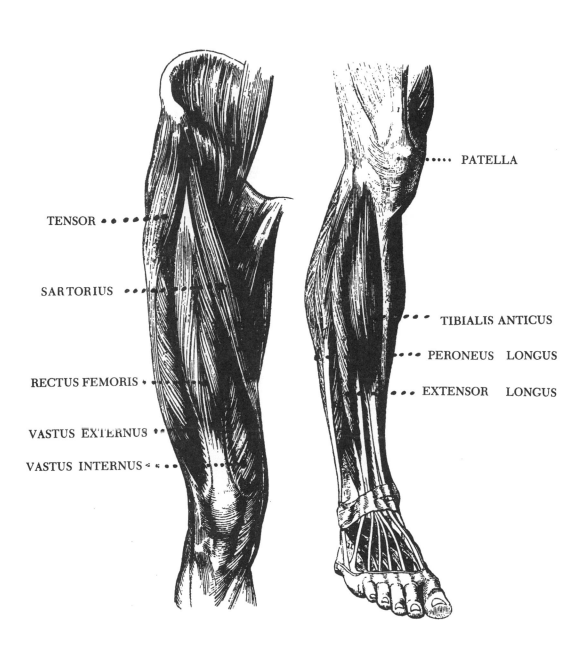

TENSOR • • • •

SARTORIUS • • • •

RECTUS FEMORIS •

VASTUS EXTERNUS • •

VASTUS INTERNUS • • •

PATELLA

• • • TIBIALIS ANTICUS

• • • PERONEUS LONGUS

• • • EXTENSOR LONGUS

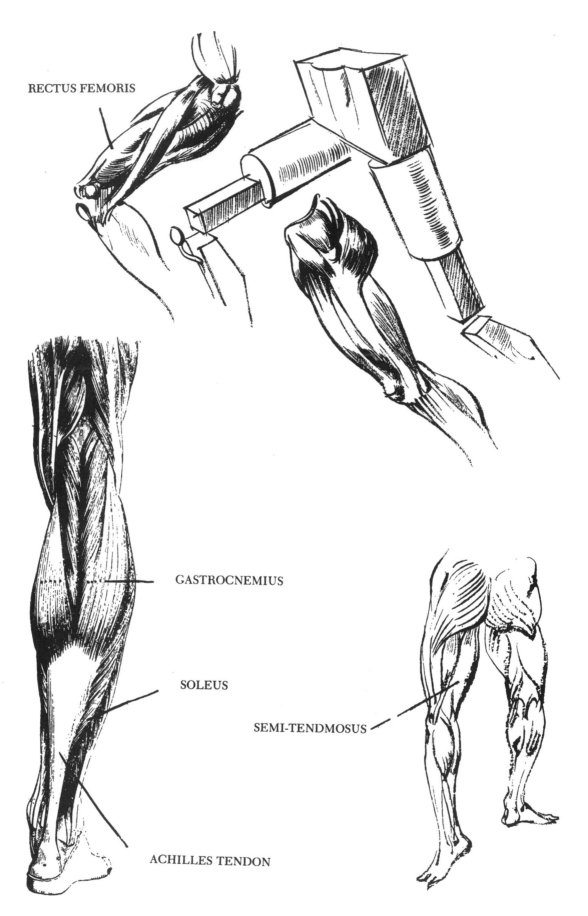

RECTUS FEMORIS

GASTROCNEMIUS

SOLEUS

SEMI-TENDMOSUS

ACHILLES TENDON

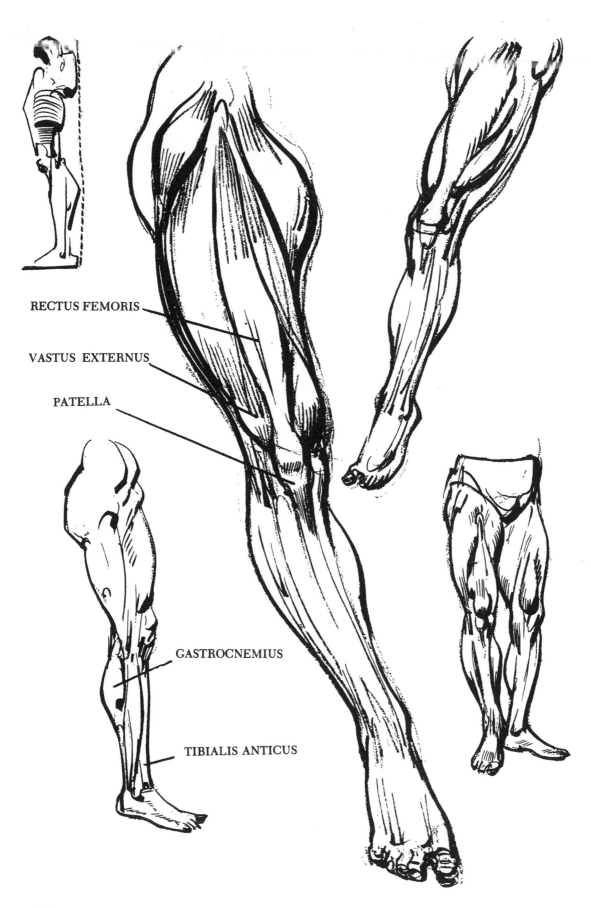

RECTUS FEMORIS

VASTUS EXTERNUS

PATELLA

GASTROCNEMIUS

TIBIALIS ANTICUS

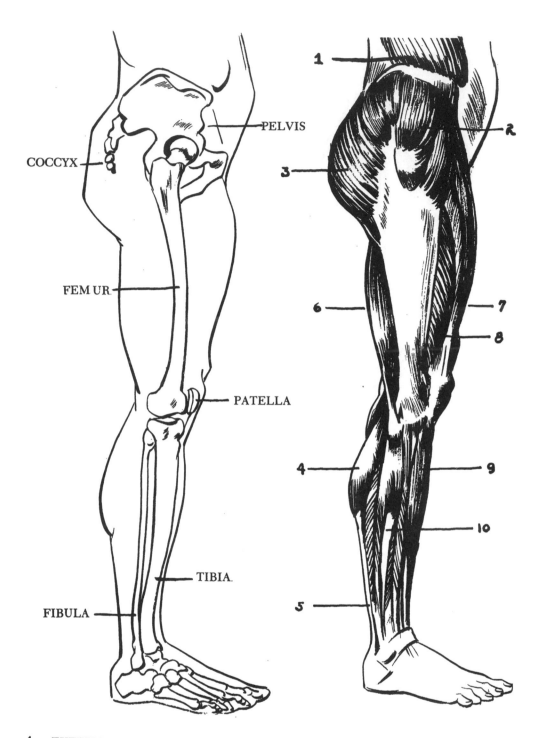

COCCYX

PELVIS

FEM UR.

PATELLA

TIBIA.

FIBULA

1 EXTERNAL OBLIQUE

2 GLUTEUS MEDIUS

3 GLUTEUS MAXIMUS

4 GASTROCNEMIUS

5 ACHILLES TENDON

6 BICEP FEMORIS

7 RECTUS FEMORIS

8 VASTUS EXTERNUS

9 TIBIALIS ANTICUS

10 PERONEUS

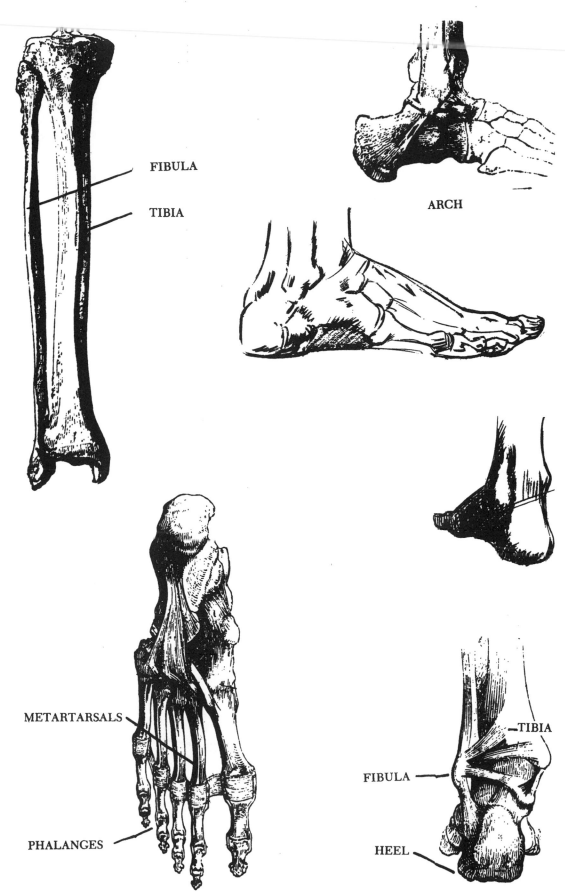

FIBULA

TIBIA

ARCH

METARTARSALS

PHALANGES

TIBIA

FIBULA

HEEL

The arm is attached to the shoulder girdle consisting of the clavicle and the shoulder blade.

The humerus (upper bone of the arm) is inserted into the cavity of the shoulder blade and is held in place by ligaments and membranes. The girdle moves with the lowering and raising the arm. The lower bones of the arm called the ulna and the radius. The ulna fits into the lower end of the humerus on top (the elbow) and the bottom is the little finger side. Next to the ulna is the radius, small at the top and large at the bottom and it rotates around the ulna and is the thumb side of the hand.

The largest part of the arm is the Deltoid muscle which is connected at the clavicle across the head of the humerus and to the shoulder blade and halfway down the humerus on the outside between the bicep and tricep.

The two large masses of the hand are the hand itself and the thumb on the back of the hand from the wrist. There is a continual step down to the fingers, the palm side of the hand is cup like in shape. On top of the hand the fingers start below where the hand bends at the knuckles, and in the palm the fingers start where the palm ends.

It is insufficient to copy anatomical drawings. One must learn the shape of each part and be able to draw the shape in any position with the understanding of perspective and know how it works.

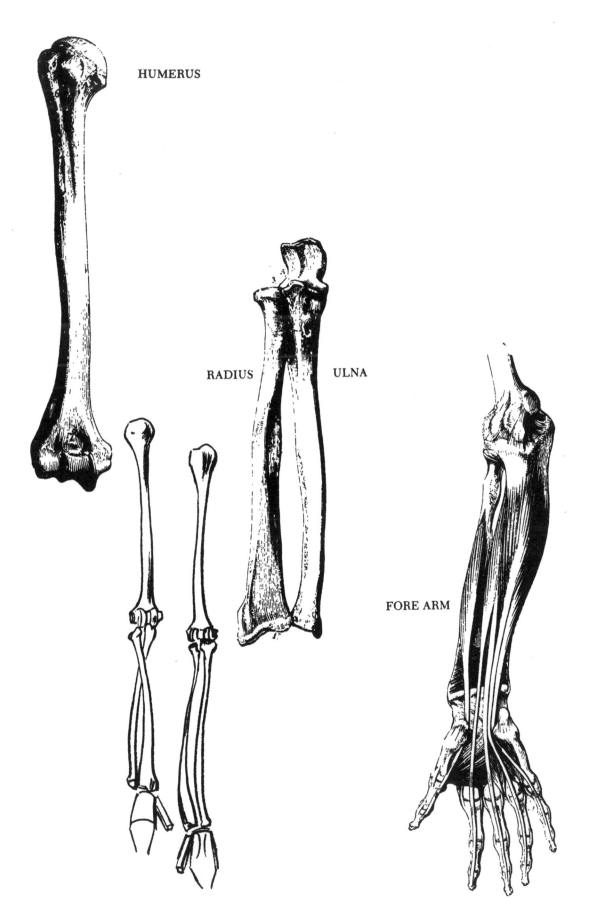

HUMERUS

RADIUS ULNA

FORE ARM

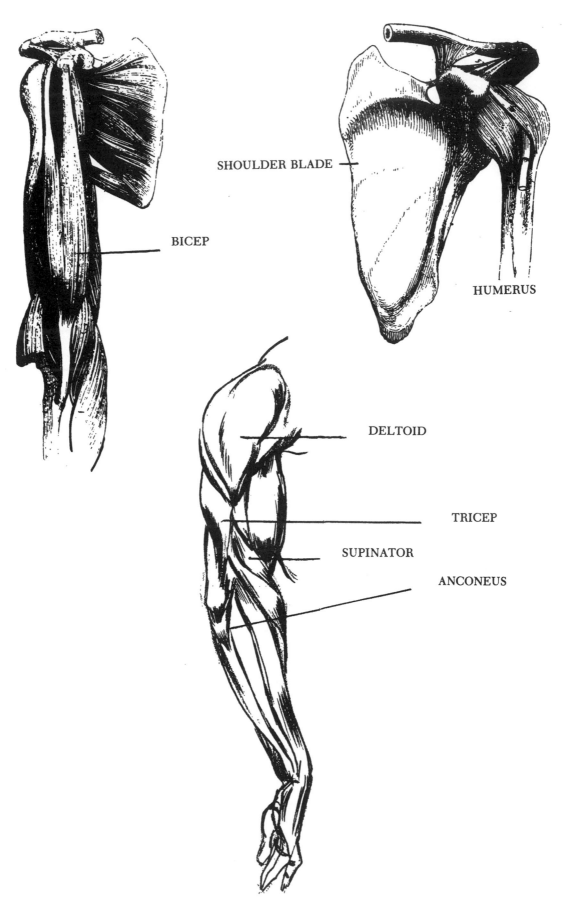

BICEP

SHOULDER BLADE

HUMERUS

DELTOID

TRICEP

SUPINATOR

ANCONEUS

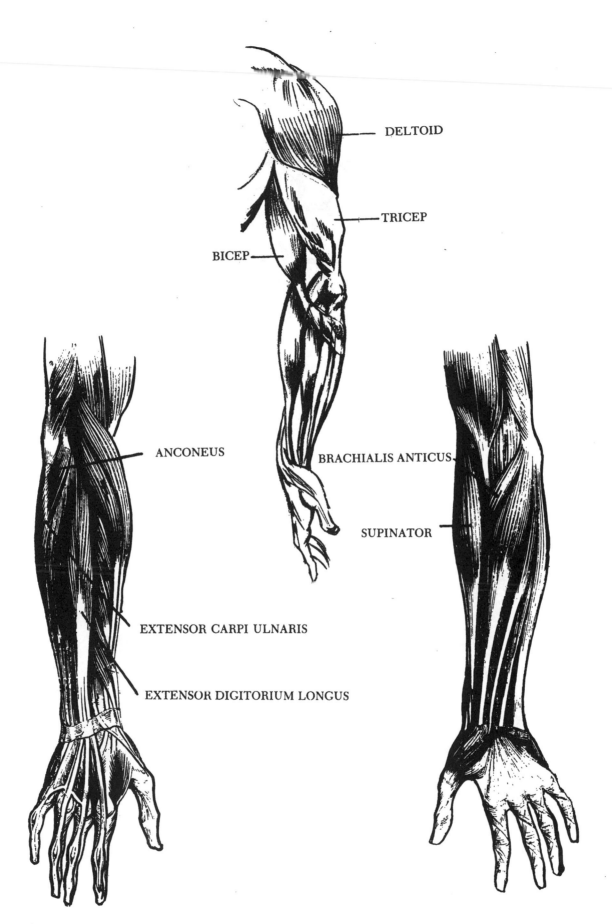

DELTOID

TRICEP

BICEP

ANCONEUS

BRACHIALIS ANTICUS

SUPINATOR

EXTENSOR CARPI ULNARIS

EXTENSOR DIGITORIUM LONGUS

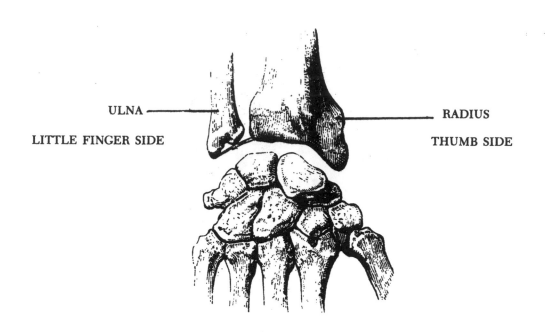

ULNA ———————————————— RADIUS

LITTLE FINGER SIDE THUMB SIDE

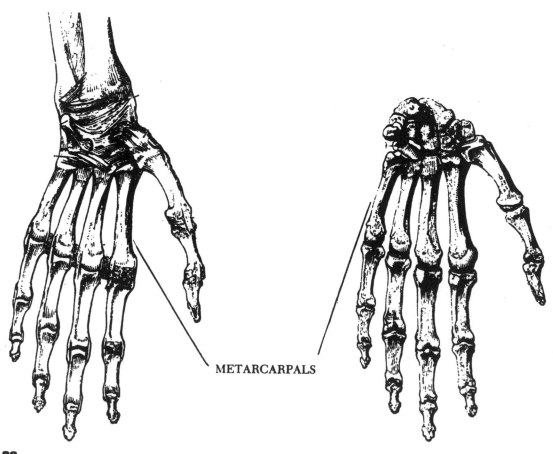

METARCARPALS

88

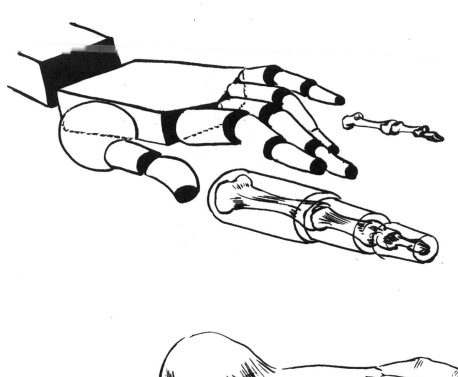

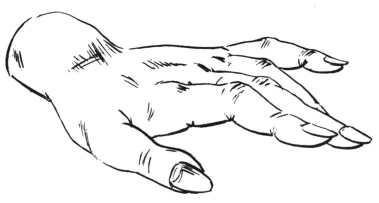

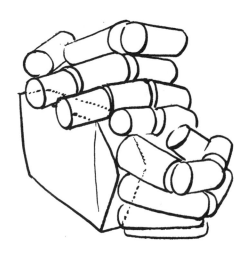

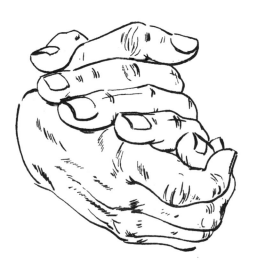

89

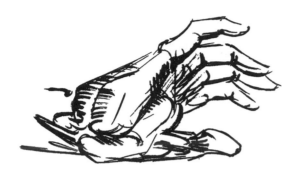

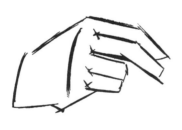

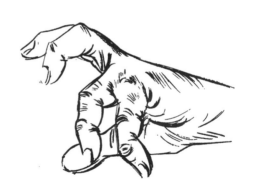

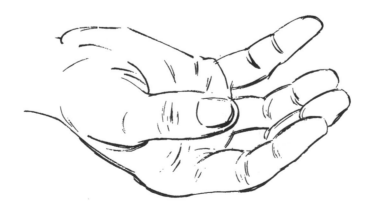

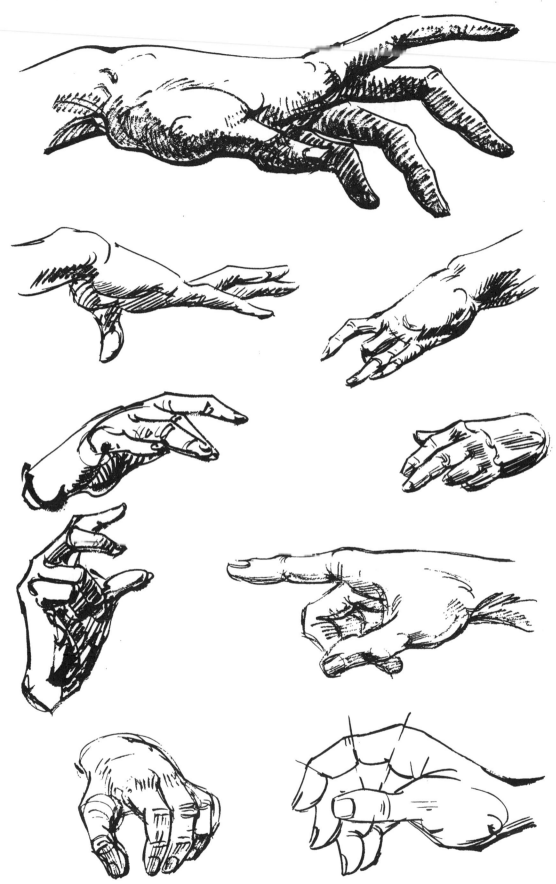

DRAPERY

After learning to draw the human figure, the knowledge of drapery plays an important part in the success of an artist. The careful studies left behind by the Masters show us how concerned they were with the laws of drapery.

All types of cloth fall into the same folds. Each fold has a character of its own. By recognizing and leaving out the unimportant and accidental folds, drapery will possess design simplicity and power. All this contributes towards the composition of a well organized picture.

When drawing the clothed figure try to understand how the body underneath affects the material that covers and surrounds it.

There are various points of attachment. Some parts of the figure are surrounded, other folds indicate stress and resistance. All these folds fall into different laws.

Cloth that drops from a fixed point results in long pipe-like forms.

When cloth is held by two points the folds drop toward each other, in diaper fashion. When a fold presses against another fold it breaks up in a zig-zag fashion. In surrounding a form half way it assumes a half cup form. The spiral fold is like a spiral around the form. Try not to repeat folds by paralleling them and keep them of different widths.

In drawing cloth that is resting on the floor, establish first the shape it covers. then build up the folds on top of it. In the following pages observe the different laws of folds. Learn to recognize them and understand them when drawing drapery.

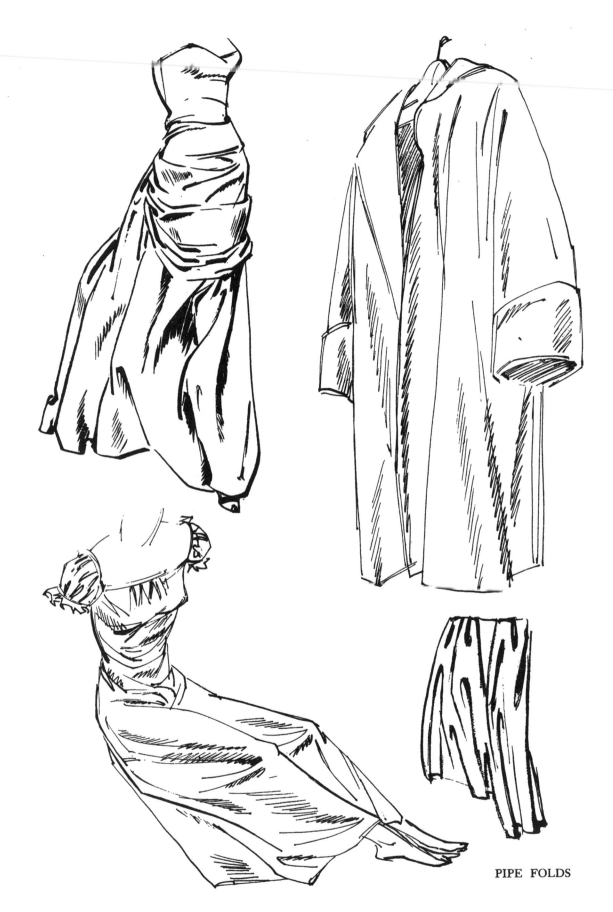

PIPE FOLDS

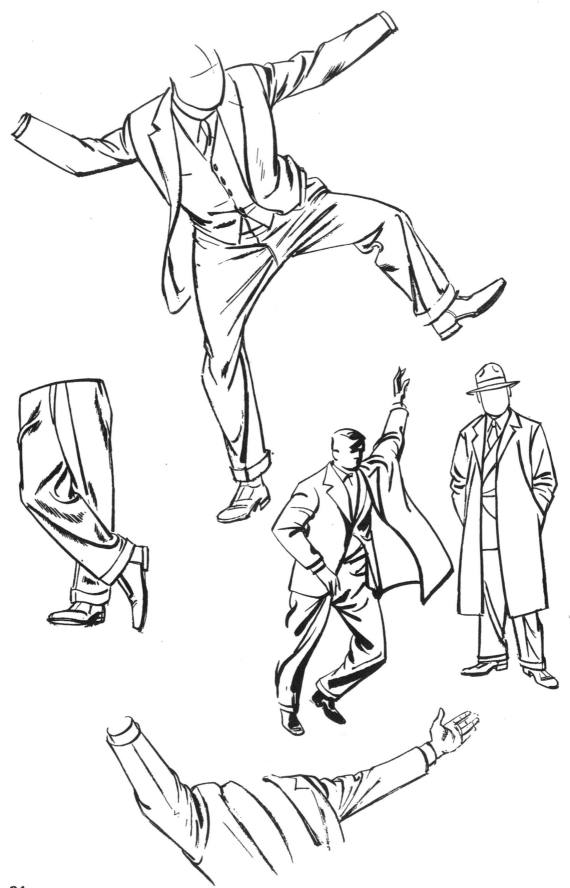

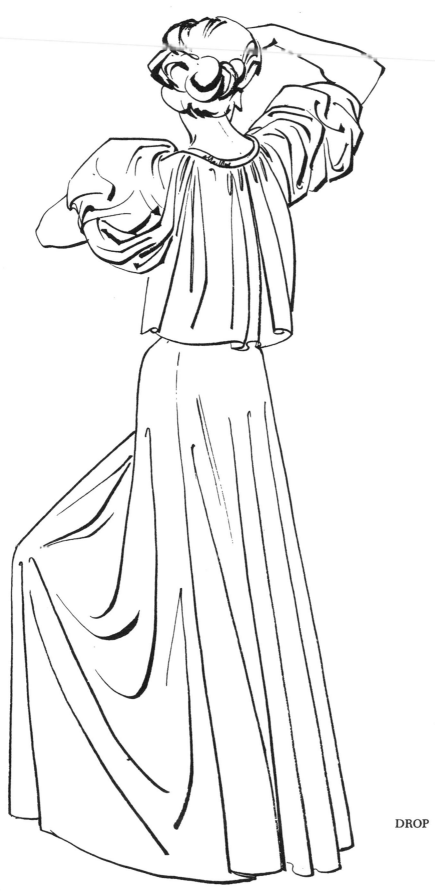

DROP

95

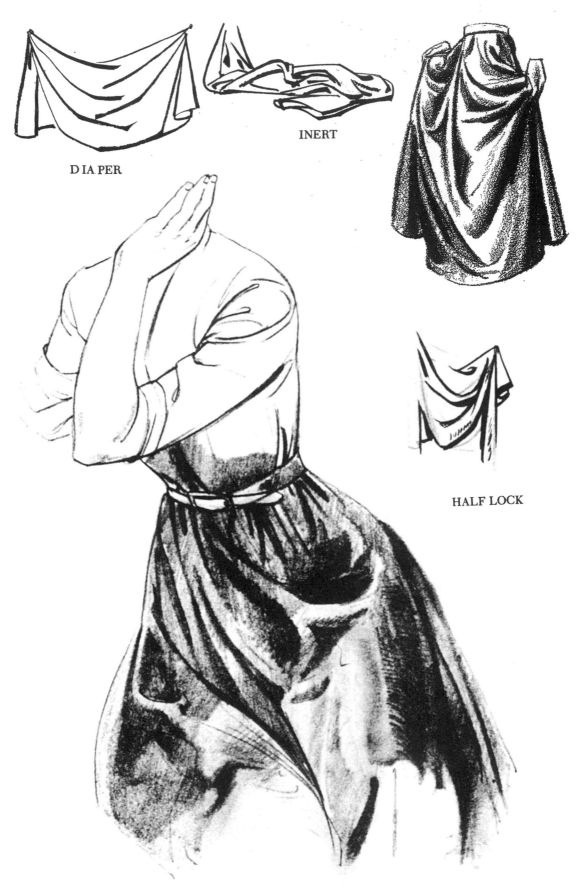

DIAPER

INERT

HALF LOCK

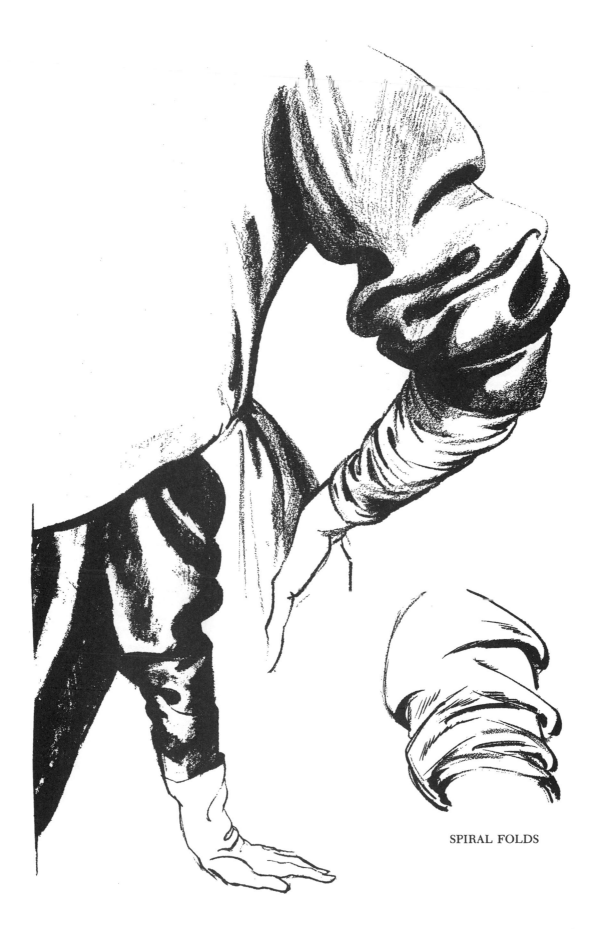

SPIRAL FOLDS

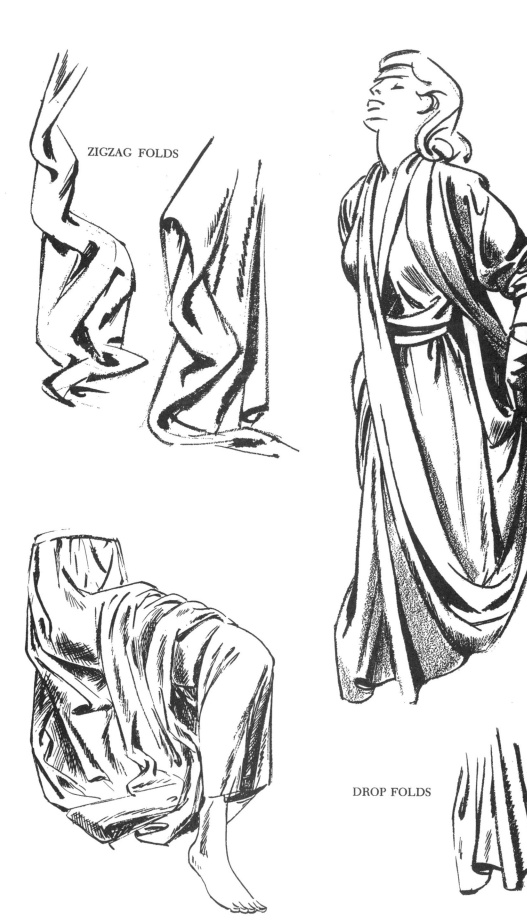

ZIGZAG FOLDS

DROP FOLDS

COMPOSITION

The main objective of every picture is to hold the attention of the viewer as long as possible. The organization of a picture contributes a great deal towards this end. The ability to create harmony, unity and balance can start with a few basic rules. The circle, the pyramid, the T, the S, the zig-zag and variations or combination of the underlying designs can help develop a sense of composition. The first rule of order to follow is to always place your subject matter in a shape that will afford the best composition. The most common mistake of the student is to use whatever size of paper a manufacturer makes. When drawing from the model, still life or landscape, and you have decided what you are going to draw, pick the size that your subject will best compose in. Drawing at random from the model results in bad amputations of the figure. Great art or good pictures are never created this way—be it a single figure or a large mural containing a great deal of subject matter. Try to imagine someone attempting to paint a mural, an illustration, or a piece of advertising art by just starting in the center of the space and allowing the composition to end at the edges. Everything from a postage stamp design to the Sistine Chapel mural had to be composed best to fill the area with the best possible design.

Numerous sketches are made in order to create a sense of balance and unity. Nature is very seldom in perfect harmony. The creative artist first makes his compositions, then gets his models and background material for study— either from life or photographs—and after a careful drawing of everything combined, proceeds to enlarge it on his paper, canvas or wall.

Volumes can be written and have been written on composition. A few basic rules on the next page merely show the underlying design. The picture content has been purposely made indistinguishable so as not to imply that a definite subject will not have a definite design pattern, for in the end, the artist must select the shape and design that will best suit his subject. The success of the picture, finally, depends upon the depth of the artist.

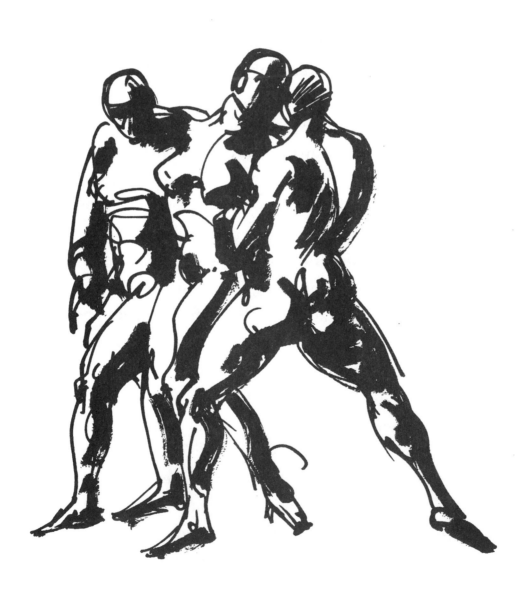

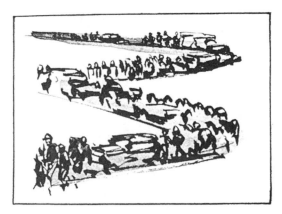

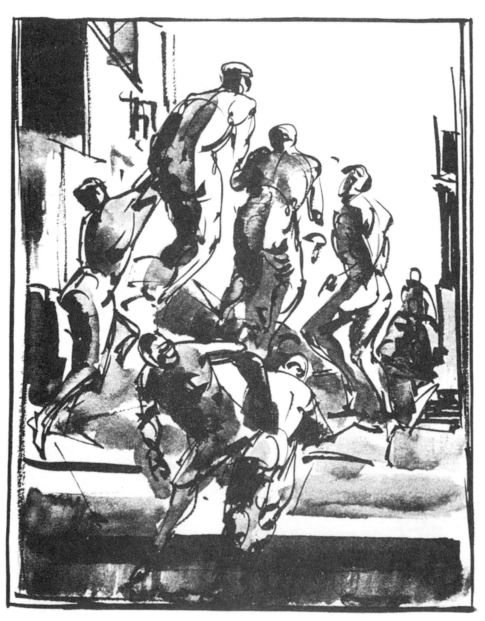

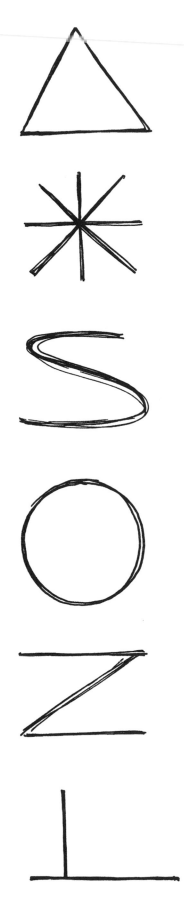

TREES AND LANDSCAPE

Learn to draw from nature. Become curious about everything that surrounds you. In drawing a house, study its construction. Apply this to everything you draw.

Do not confuse a sketch with a study. A sketch should be made for a composition. A study is made to understand how it is constructed. We learn most when making a study, this also applies to nature.

Page 106 shows a simple approach in concept of how branches grow on a tree. Notice that branches grow out in different directions. North, East, South and West and that every form regardless of its shape is affected by light. Such as a group of leaves, a barn or locomotive.

Do not depend entirely upon a photograph or another picture. Learn to draw from the actual subject matter. The visual impact and the knowledge of construction will make it possible for a better interpretation. There are times when a small stone or a branch from a tree can serve as a model for a mountain or a tree. The difference will be in size.

On page 107 by placing two small figures at the base of a branch, it suggests a tree. Cover the two small figures with your thumb and notice that it suggests a branch again.

Words could not express how the bark of a tree, or snow feels when touching them, personal contact will give you a better understanding of subject matter.

A great percentage of the world of art was created before the invention of the camera.

Learn to draw everything that surrounds you in your daily life. Learn the basic laws that govern their construction. The more you understand it, the better equipped you shall be able to create pictures.

The following pages are from my note books. Some are studies, others served as basis for composition and lighting and others for pure enjoyment.

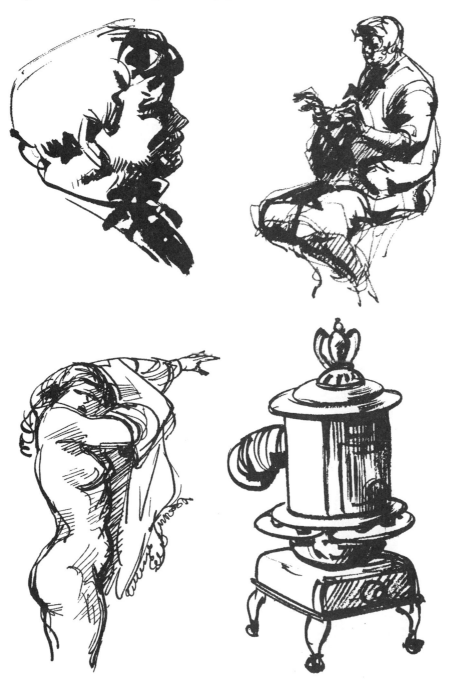

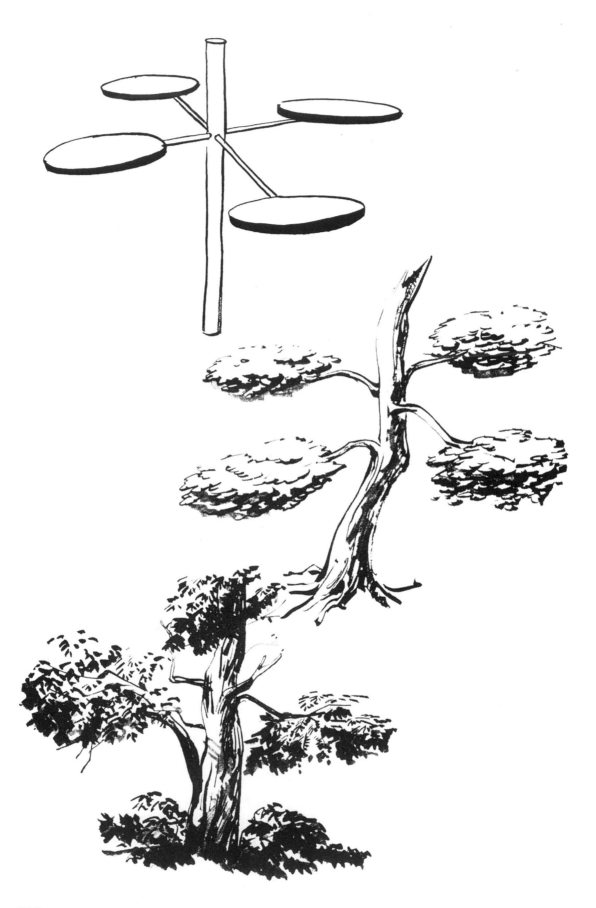

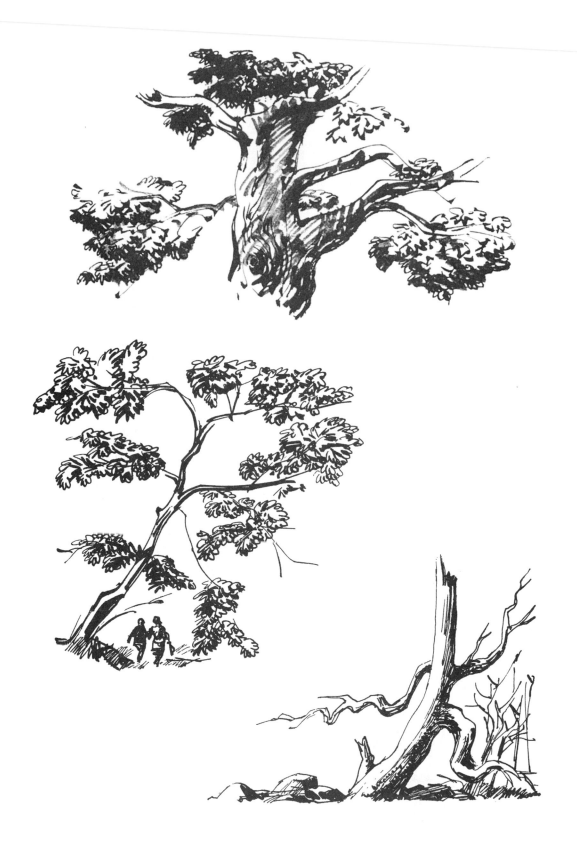

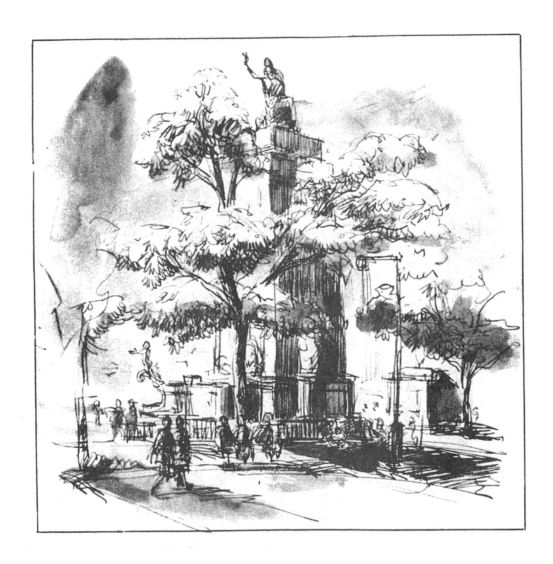

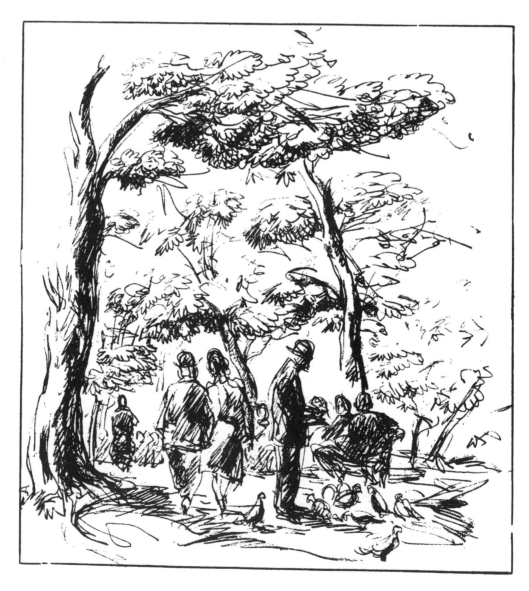

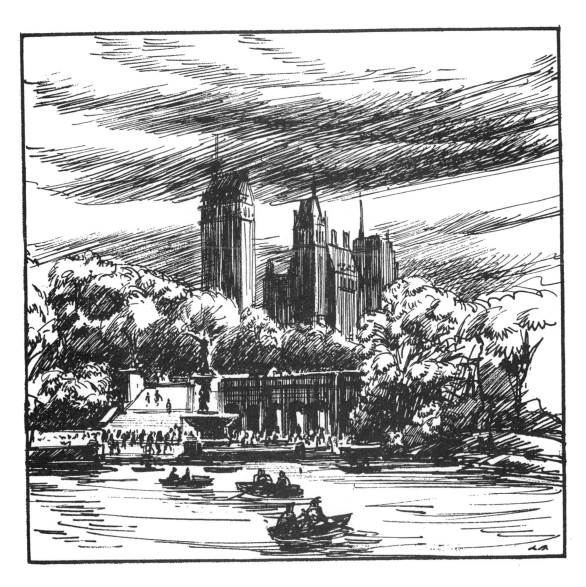

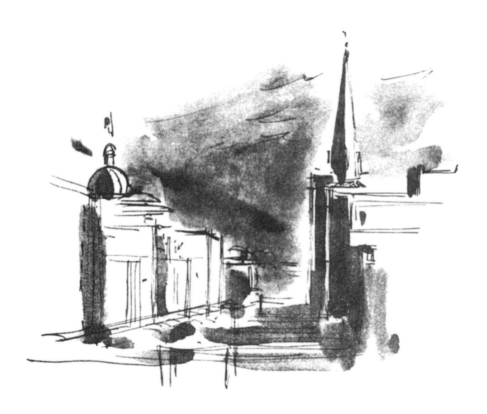

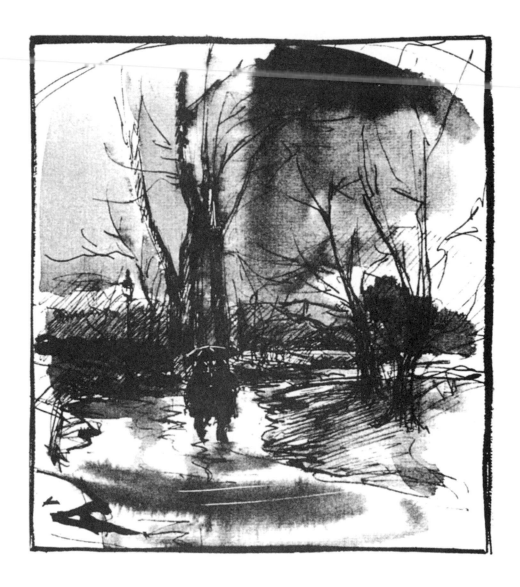

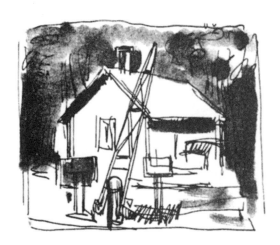

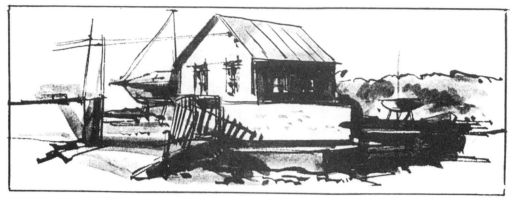

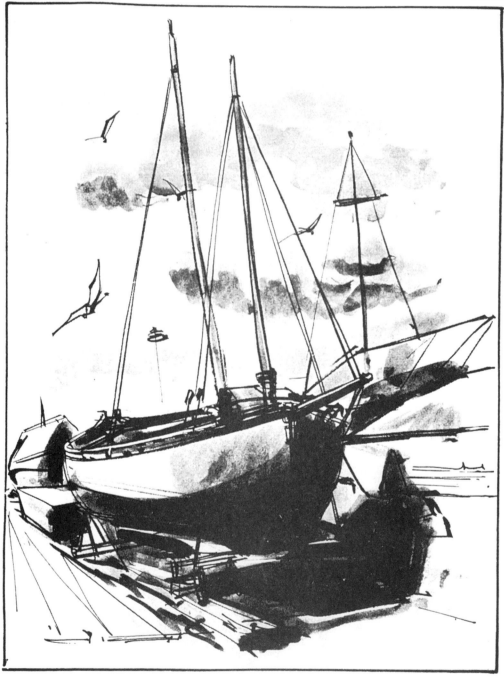

OUTDOOR SKETCHING

The carrying of a sketch book will play an important part in your growth as an artist. It is a shorthand method of recording the relationship between yourself and the world you live in. Every observation you record by making a sketch contributes toward your dexterity and ease of self-expression. Make constant sketches from unposed models: the people who surround you in your daily life. No doubt you will feel self-conscious in the beginning; but you can overcome this by first sketching your family and close friends while they go about their everyday tasks. Try to sketch them without their knowing it, for only then will they express what they are doing in a natural way. Sketch everyone from the beggar to the banker. You will find that people's expressions and gestures fit their occupation. You will observe that a person will sit differently in different places—for example, notice how a man will sit in church compared with how he will sit at a ball game. Hand expressions will also be different. There are times when a person's hands will reveal a truer expression of his thoughts than his face will show.

Learn to make rapid sketches of people in action. In order to improve your sense of composition, first start by sketching two people together—sitting at a dinner table, perhaps, or standing in conversation. You will notice that usually they will be of a different height and weight and possess entirely different characteristics.

Later, draw three people together, After you have done a great deal of sketches, you will find that making a record of a crowd will not be difficult. Make sketches of street scenes and all inanimate objects about you to develop

your architectural sense and sense of construction. A few notes with your sketches describing the person or thing will also increase your power of observation and memory. All these things will better equip you to create better pictures.

As you know, Leonardo Da Vinci in his painting, "The Last Supper", did not have all the models seated around the table in order to make sketches.

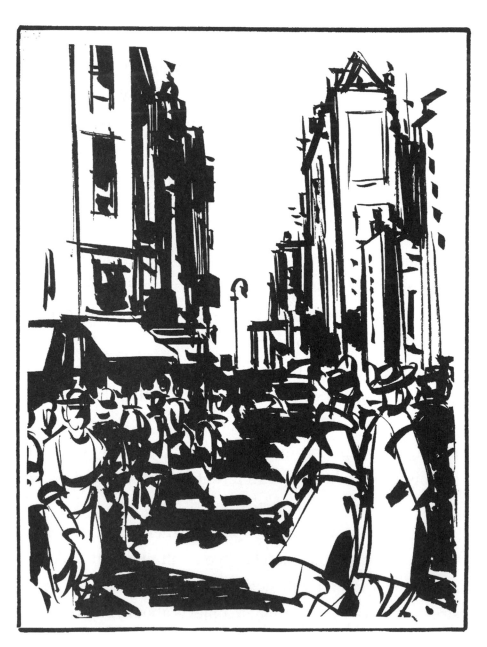

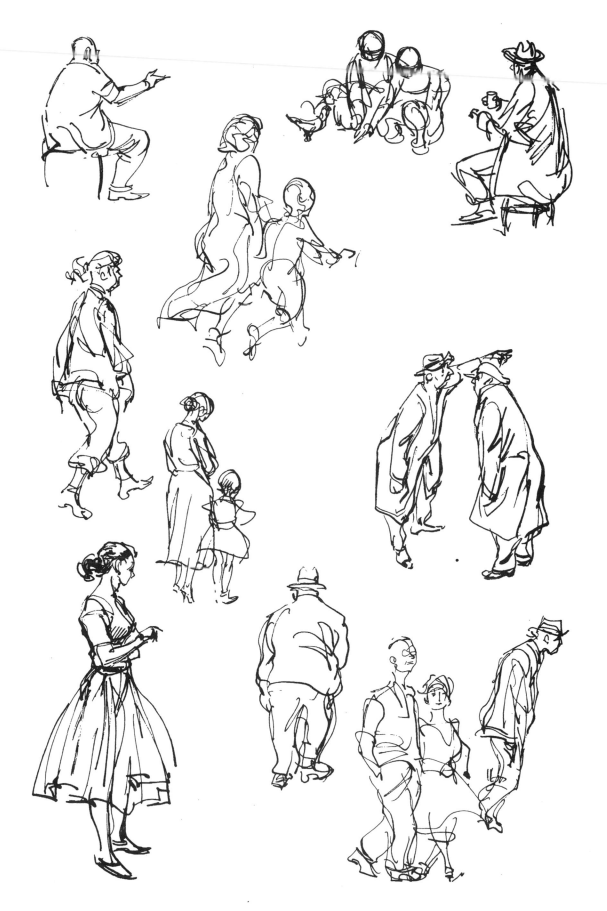

117

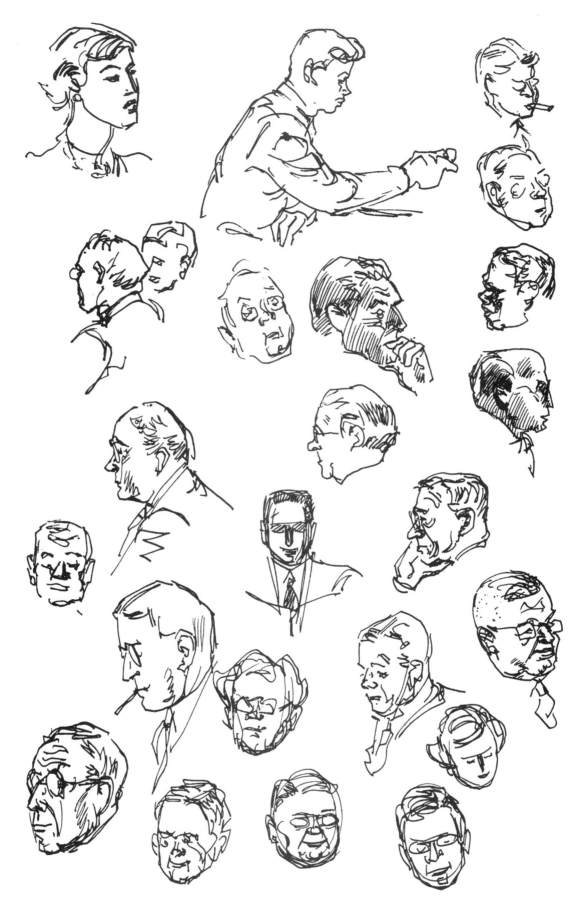

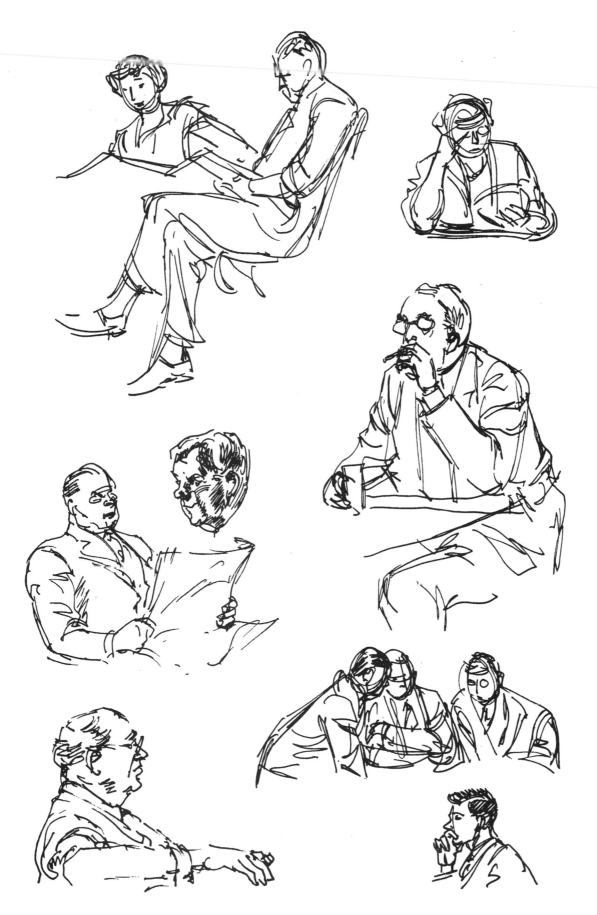

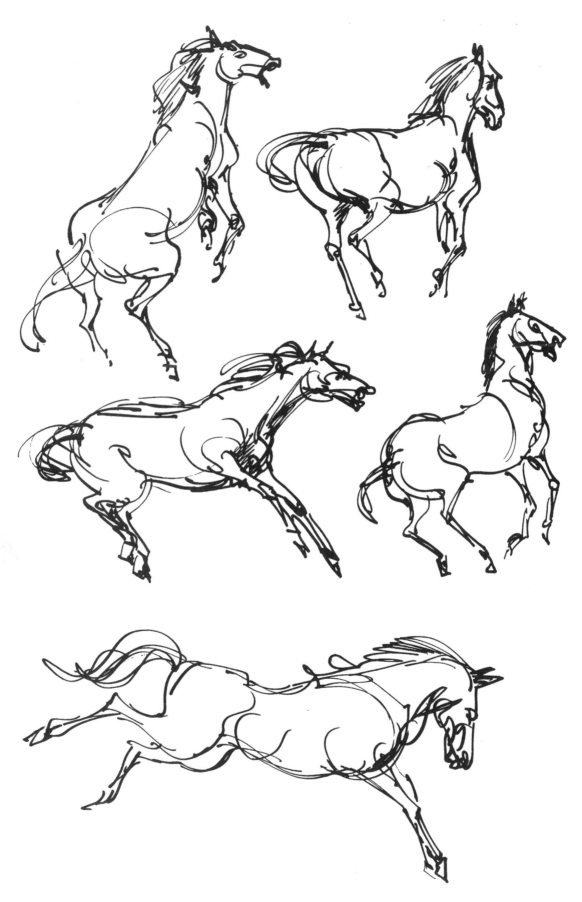

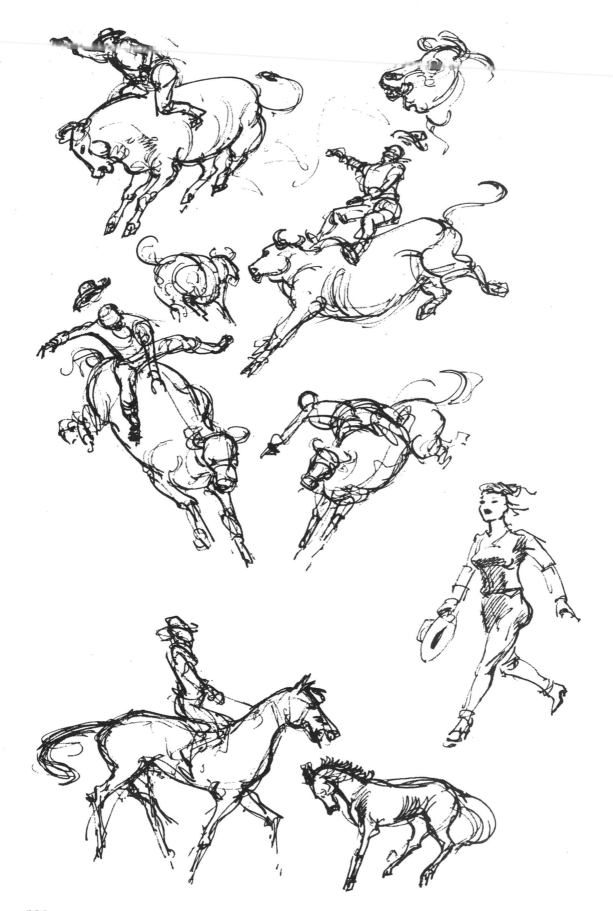

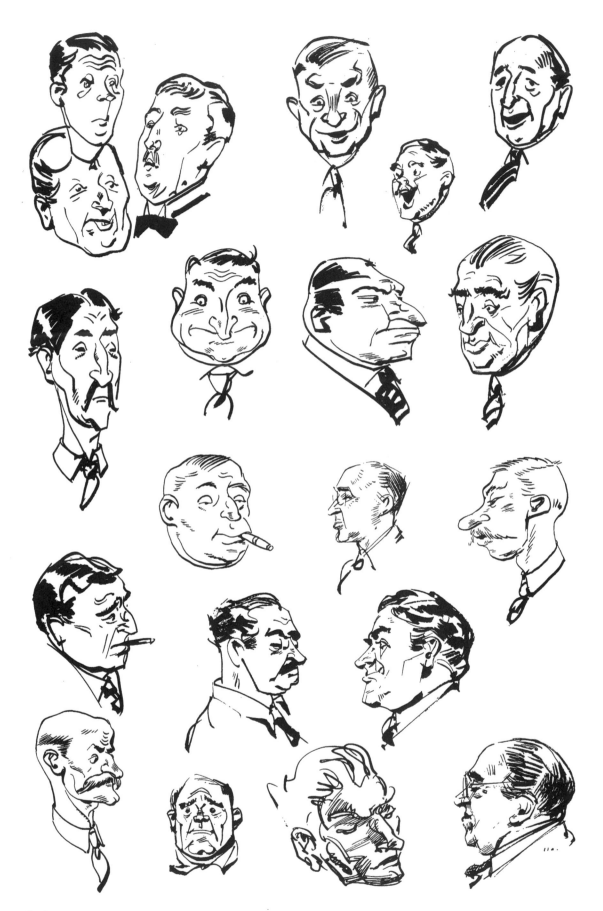

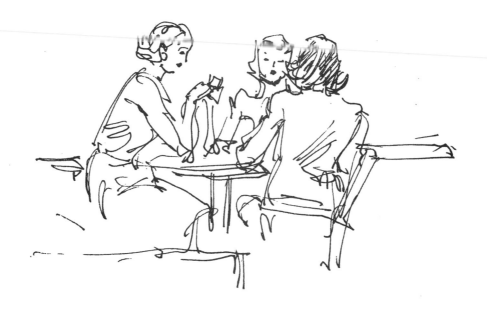

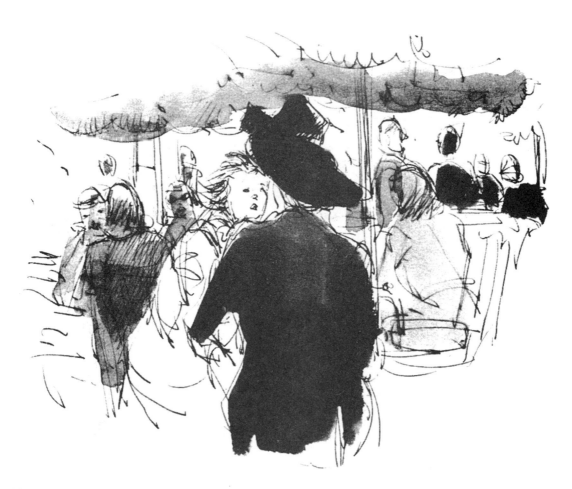

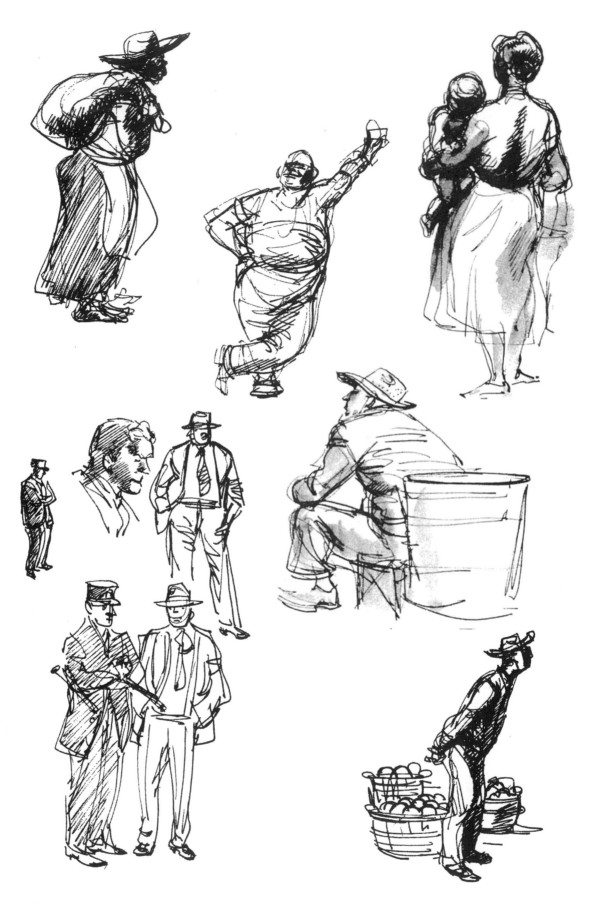

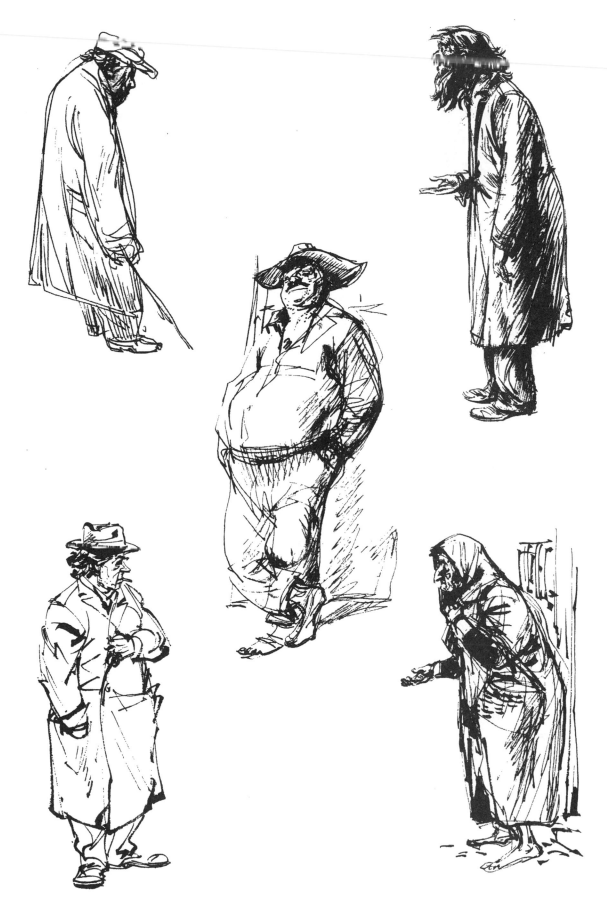

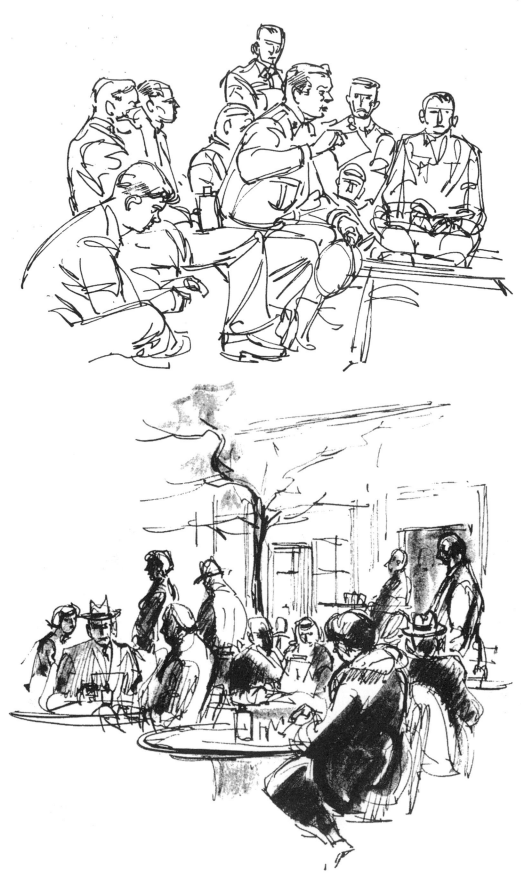

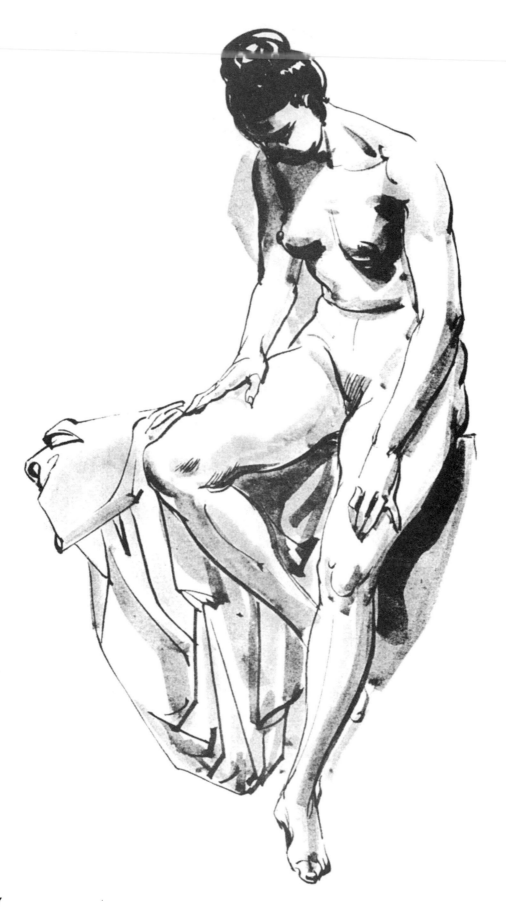

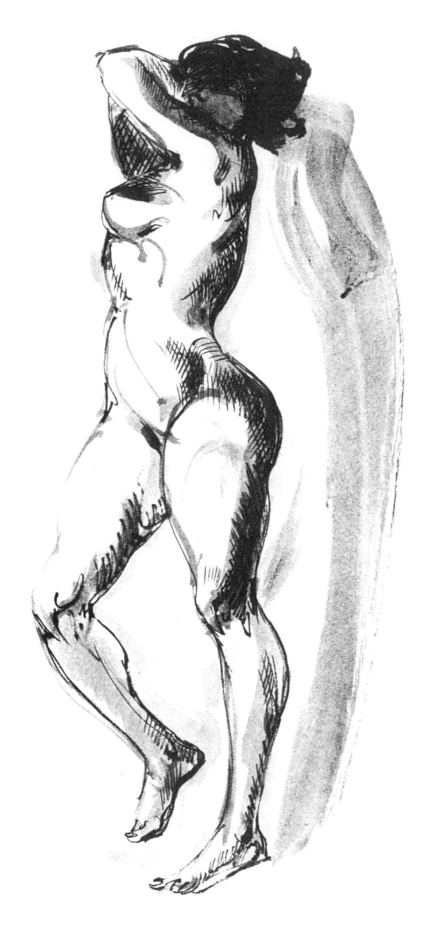

128